CHAOS AND AWE

THE MIT PRESS
Cambridge, Massachusetts
London, England

FRIST CENTER FOR THE VISUAL ARTS
Nashville, Tennessee

CHAOS AND AWE

PAINTING FOR THE 21ST CENTURY

EDITED BY **MARK W. SCALA**

with essays by Media Farzin, Simon Morley, and Matthew Ritchie

Published in conjunction with the exhibition *Chaos and Awe: Painting for the 21st Century*, organized by the Frist Center for the Visual Arts, Nashville, Tennessee. The Frist Center for the Visual Arts gratefully acknowledges the generosity of the Friends of Contemporary Art.

Support for the Frist Center of the Visual Arts is also provided by

This book was set in Helvetica Neue by the MIT Press. Printed and bound in Italy.

Library of Congress Cataloging-in-Publication Data

Names: Scala, Mark, editor. | Farzin, Media. | Morley, Simon, 1958– | Ritchie, Matthew, 1964–
Title: Chaos and awe : painting for the 21st century / edited by Mark W. Scala.
Description: Cambridge, MA : The MIT Press, 2018. | Includes bibliographical references.
Identifiers: LCCN 2017026380 | ISBN 9780262534970 (pbk. : alk. paper)
Subjects: LCSH: Painting, Modern--21st century--Themes, motives. | Art and society--History--21st century.
Classification: LCC ND196.2 .C42 2018 | DDC 759.06--dc23 LC record available at https://lccn.loc.gov/2017026380

10 9 8 7 6 5 4 3 2 1

CONTENTS

FOREWORD

Each generation faces a degree of uncertainty and threat. Lately, globalization and technological connectivity have not ensured peace and tranquility, but rather seem to have fostered mistrust, radicalism, reactionary politics, a disregard for the fragility of the environment, and even the possibility of a nuclear autumn, if not annihilation. Visual artists respond to current events and issues in myriad ways, employing a range of materials and strategies to render or conjure overt or symbolic associations. It is not unheard of to encounter contemporary art made with an iPhone, lasers, or consumer refuse. Nevertheless, in this no-holds-barred moment, we cannot ignore the persistence of painting. The art in *Chaos and Awe: Painting for the 21st Century* is so effective in addressing contemporary concerns that we cannot imagine a more appropriate currency.

Most survey courses in the history of art begin with cave paintings, the earliest examples of markings, carvings, and tracings on uneven walls sometimes capturing a likeness of an animal and sometimes recording a stenciled handprint to affirm the physical presence of the creator. At a time when nature was at least as threatening as it was awe-inspiring, our ancient ancestors felt the need to anchor themselves against the vastness of the unknown by using gestures. We must acknowledge that through the ages and a succession of -isms in modern times, painting has remained relevant in some if not all circles, despite periodic claims that it had reached an end game.

Today, it is undeniable that the primacy of painting is worthy of the thoughtful contextualization proposed by chief curator Mark Scala. *Chaos and Awe: Painting for the 21st Century*, on view at the Frist

Center for the Visual Arts from June 22 to September 16, 2018, reflects his sentient and visceral understanding of how painting helps us make connections between the world around us and our innermost feelings. Scala is a painter's curator. He honors the artist's intentions and respects the viewer. We are rewarded for our careful looking and attention to his inventive curatorial enterprise and the case he makes for the efficacy of painting as a powerful means of nonverbal communication.

Chaos and Awe follows a series of three exhibitions organized by Scala since 2009, on the human body in recent and contemporary art. The titles *Paint Made Flesh* (2009), *Fairy Tales, Monsters, and the Genetic Imagination* (2012), and *Phantom Bodies: The Human Aura in Art* (2015) may seem disparate; however, each is a prelude to *Chaos and Awe*. *Paint Made Flesh* is the most direct correlation, for it featured paintings made in the United States and Europe in the period between 1945 and the end of the 20th century, in which paint was equated with emotional conditions. In *Fairy Tales, Monsters, and the Genetic Imagination*, Scala explored the unsettling aspects of genetic engineering and hybridization that destabilize our sense of predictability. And finally, *Phantom Bodies* was concerned with longing, loss, and the desire for transcendence, feelings that resonate equally in many of the works in *Chaos and Awe*.

Both the paintings in the exhibition and the written contributions to this accompanying book explore the contradictions in the human experience of disturbance/familiarity, dislocation/connection, and disorientation/wonder. Our responses to universal concerns are inseparable from our physical safety and sense of place in the world. The only fears we are born with are the fear of falling and the fear of loud noises, which provide innate protection against imminent danger. An infant is totally dependent initially, and only over time and with the emergence of the ego does a child understand the boundaries of its own body. Our specific fears, anxieties, and phobias come about as the result of threats to our identity or safety. Yet, it is in the revelation that we are, in fact, part of a greater whole that we experience both awe and our insignificance, once again setting up the tension of contradictory emotions. Scala restores the resonance of the word *awe* from the vernacular, returning it rightfully to the full measure of its meaning, just in time.

Neither the exhibition *Chaos and Awe* nor this book would have been possible without the full support of the Board of Trustees at the Frist Center for the Visual Arts, particularly chair and president Billy Frist. Mr. Frist believes strongly in supporting original research and curatorial freedom, something we never take for granted. This is our first publication with the MIT Press. We are deeply honored to work with an organization renowned for intellectual integrity and rigor. Generous and unrestricted

funding allows the curatorial team to take risks and rest assured that their projects will come to fruition. For that luxury, we gratefully acknowledge the Frist Foundation, as well as the Metro Nashville Arts Commission, the Tennessee Arts Commission, and the National Endowment for the Arts. Mark Scala has my gratitude and respect for this project and his passion for the ageless efforts of humanity to make a mark.

SUSAN H. EDWARDS, PhD
Executive Director and CEO
Frist Center for the Visual Arts

ACKNOWLEDGMENTS

In developing a thematic exhibition, a curator may begin by recognizing in a few artworks a compelling idea, an unexamined corner of the cultural imagination. Readings, studio visits, and conversations widen the field of play, and what began as inchoate feeling becomes formulated into what we at the Frist Center call "the big idea." My big idea began as a meditation on painting as a medium well suited to expressing the interconnectedness of life in the 21st century. Initially, this idea was embodied in the word *interzone*, a term meant to suggest that the bonds of society exist in the invisible energy flowing between things, people, and systems. But a more nuanced, layered, and less comforting theme began to emerge. It was artists who led me down this path, who showed that chaos and entropy can potentially disrupt any sense of cohesion, acknowledging an unpredictability that is in the end an intrinsic, dark, yet alluring part of the human paradox. My first nod of thanks goes to all those in the exhibition who give form to the energy that flows between creation and dissolution.

The intellectual heavy lifting came as I engaged with the catalog contributors, who took my sketch of an idea and helped give it a philosophical and political coherence. My thanks to Media Farzin, Simon Morley, and Matthew Ritchie for their truly thoughtful essays, which confirm a sense of high purpose in painting, seeing in it an apt metaphor for making the framing of perception and consciousness into something as uncertain as actual lived experience. Together, we have produced this book, which has been published by the MIT Press. Working with art editor Victoria Hindley has been gratifying. From the moment we first spoke, Victoria saw the potential for a general

readership, as the book discusses painting not just in the context of the art world or through academic analysis, but more broadly as an allegorical means that might help anyone come to grips with society's increasingly precarious sense of coherence. My thanks to the entire MIT team, who added this modest book to their distinguished catalog.

My thanks also to all the lenders, who are listed elsewhere in this book. More personally, I am grateful to the following museum workers, gallerists, and studio representatives who were generous with their time and assistance: at Albright-Knox Art Gallery, Janne Sirén, Cathleen Chaffee, and Catherine Scrivo Baker; at Andrea Rosen Gallery, Laura Lupton and Amy Ontiveros; at Barbara Gladstone Gallery, Caroline Luce; at The Broad, Joanne Heyler and Vicki Gambill; at Clearing, Max Bushman and Harry Scrymgeour; at Curator's Office, Andrea Pollan; at DC Moore Gallery, Heidi Lange; at Gagosian Gallery, Larry Gagosian, Chrissie Erpf, and Isabelle Edwards; at Hall Art Foundation, Maryse Brand; at Hallmark Art Collection, Joe Houston; at the High Museum of Art, Randall Suffolk and Michael Rooks; at Indianapolis Museum of Art, Charles Venable and Sherry D'Asto Peglow; at Koenig & Clinton, Margaret Clinton; Leslie Tonkonow at her gallery; at Marian Goodman Gallery, Abigail Donahue and Emily-Jane Kirwan; at Mildred Lane Kemper Art Museum, Sabine Eckmann; at Mott-Warsh Collection, Maryanne Mott and Stephanie James; at Nerman Museum of Contemporary Art, Bruce Hartman; at October Gallery, Elisabeth Lalouschek; at Paula Cooper Gallery, Anthony Allen; at Peter Halley Studio, Scott Dixon; at Petzel, Sam Tsao; at Pierogi, Joe Amrhein; at the Pizzuti Collection, Ron Pizzuti and Brittany Snider; at the Solomon R. Guggenheim Museum, Richard Armstrong, Susan Davidson, Sara Raza, and Joan Young; at 303 Gallery, Kathryn Erdmann; at Victoria Miro, London, Catherine Turner; at Worth Advisory Group LLC, Candace Worth; and at ZieherSmith, Scott Zieher and Andrea S. Zieher.

We are delighted that *Chaos and Awe: Painting for the 21st Century* will be presented at the Chrysler Museum of Art in Norfolk, Virginia, in the fall of 2018 through the spring of 2019. I thank Erik H. Neil, director; Lloyd DeWitt, chief curator and Irene Leache Curator of European Art; and Kimberli Gant, McKinnon Curator of Modern and Contemporary Art, and look forward to working with these distinguished colleagues to engage their audience with paintings that speak so clearly to our own time.

Finally, those close to home: thanks go to our board president and chair Billy Frist and executive director and CEO Susan Edwards, who, believing that curators should follow their passions, move mountains to make this happen; registrar Richard Feaster; exhibition designer Hans Schmitt-Matzen; graphic designer Brandon Gnetz; managing editor Wallace Joiner and editor Peg Duthie; head preparator Scott Thom and preparators Shane Doling and Dooby Tomkins; and indeed to all my colleagues

who continue to bring art to the public through programs, communications, fund-raising, and all the other efforts that transform an exhibition from a conceptualization into a cultural organism. As ever, we express our gratitude to the Metro Nashville Arts Commission, the Tennessee Arts Commission, and the National Endowment for the Arts for their ongoing support.

MARK W. SCALA

INTRODUCTION

MARK W. SCALA

The forces of media, capital, and culture swirl about us like massive storms of images. We know more about the world now than ever before, just as it seems to be more than ever escaping our comprehension, much less control.

W. J. T. MITCHELL

So we have no alternative but to accept the world as an abyss and a situation that is always precarious . . .

ALBERTO RUIZ DE SAMANIEGO

In this hypothetical exchange, the 21st century is represented as awash in data and yet drowning in incomprehension. Increasingly hard to define, this paradoxical state has instilled in many people a profound anxiety, even dread, as the most devastating consequences of cultural entropy become increasingly imaginable. But its very mystery may also occasion excitement at the open field, where new knowledge and surprising leaps of connectedness might take us in unanticipated directions, perhaps even on the labyrinthine path toward wisdom.

To navigate this sea of fear and possibility, we might first reject the idea of history as a reliable prognosticator. Art historian and philosopher Jacques Henric's warning against too definitive an understanding

of the past is equally applicable to the lessons we draw from it: "Beware of a linear conception of history, of its dead horizontality, of the constitution of a space that is not discontinuous, multidimensional, changing, contradictory."[1] Even with this caution in mind, we can understand the desire to return to a more certain worldview that has recently inspired nationalist sentiments in the United States and Europe as a potent reaction to our volatile situation, to try to push it back into a historical framework that hindsight tells us was simpler, perhaps purer. Yet it is no small irony that nationalist rhetoric describes a vision of heightened security and cultural retrenchment, at the same time sowing widespread unease as global forces of stability seem increasingly under siege. Fear may be replacing hope as the determining mechanism for the future (figure 0.1). But although the threat of chaos seems closer than it has in most living memories—at least in places founded on the rule of democracy and law—we may also entertain the possibility that this threat is more spectral than real. Chaos may simply describe the feeling of being at the mercy of a convoluted network of systems, sensations, beliefs, and events that are connected in ways we do not fully understand, but are, nevertheless, governed by some set of guiding principles, however abstruse they may seem.

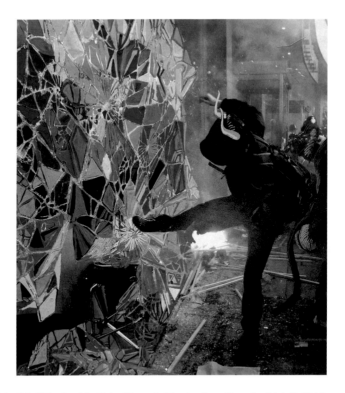

0.1 Rokni Haerizadeh, *But a Storm Is Blowing from Paradise* (detail), 2014.

The absence of clarity opens the door to the imagination, leading creative people to devise languages to describe this contingent condition, to fill the gap between knowledge and feeling. *Chaos and Awe: Painting for the 21st Century* includes sixty-one works of art that induce sensations of disturbance, curiosity, and expansiveness. This international array of artists visualizes metastasizing ideologies and virulent conflicts, the interweaving of physical reality and the digital realm, and the deepening of consciousness as limitations dissolve and categorical understandings expand (figure 0.2). The conditions they illustrate lie within a network that philosophers refer to as the social imaginary: abstract forces such as economics, philosophy, history, law, language, and ideals, which serve to bind society. Today, as we are inundated with contradictory information and warring extremisms, a growing proportion of the social imaginary feels amorphous, less the connective tissue it perhaps once was than what Zygmunt Bauman defines as a "liquid modern society," a roiling human ocean where these significations appear to be as dispersing as they are cohering.[2]

For many, the contemplation of such oceanic forces may trigger a feeling that resembles that of the *sublime*, a word that has traditionally referred to the sensation of being overwhelmed by the ungraspable and limitless power of God and the

0.2 Rachel Rossin, *I Came And Went As A Ghost Hand (Cycle II)* (detail), 2015.

cosmos. The sublime is as much associated with fear as with astonishment. Philosopher Edmund Burke wrote that the feeling of the sublime may come from contemplating "whatever is in any sort terrible, or is conversant about terrible objects, or operates in a manner analogous to terror."[3] But frightening stimuli are not the sole trigger for the arousal of sublime feelings. Philip Shaw writes that the sublime "refers to the moment when the ability to apprehend, to know, and to express a thought or sensation is defeated. Yet through this very defeat, the mind gets a feeling for that which lies beyond thought and language."[4] Paintings that thus show an ambiguous relationship between presence and absence—of control, comfort, even of words to speak—affirm that what we see and know are only slices of a more complete, and slippery, gestalt.

At a time when any still or moving picture can be created with advanced imaging technology, does painting's immobility and concreteness make it a medium well suited for portraying the ungraspable? Artist and writer Jeremy Gilbert-Rolfe doubts it: "Sublimity lies in the uncontainable, and it is the electronic rather than nature that nowadays provides . . . the experience and image of that which is larger than oneself and out of control."[5] Yet painting's limits may be its strengths (figure 0.3). Critic Caroline A. Jones writes of painting's "surprising capacity, even now, to summon for its viewers an evocative virtual world," yet one with "material heft." "There is something newly magical about a nonelectronic virtuality," she says. "It summons both a kinesthetic and an imaginative response."[6]

0.3 Corinne Wasmuht, *Bibliotheque/CDG-BSL* (detail), 2011.

In his essay in this catalog, "The Brain Is Wider Than the Sky," Simon Morley equates the rectilinear borders of paintings to those of pages, computer screens, and other formats that provide information in manageable doses, which we understand to be distillations, symbols, or indices of the larger world beyond the frame. The geometrical boundaries of our information and entertainment delivery systems also correlate to the limits of what our eyes can perceive with clarity. They focus on what is in front of them, those places at which the mind directs them to look because what is less centered in our sights is less necessary to our purposeful functioning—a mechanism that Morley, citing the neurophilosopher Thomas Metzinger, describes as the "ego tunnel." If the nationalist perspective of the world is a cultural ego tunnel, blocking awareness of peripheral forces that can challenge a singular worldview, then allowing that there is valuable information outside the focal area can be "potentially dangerous to the status quo, and . . . therefore a source of anxiety," says Morley. Yet our individual and collective vision allows for glimpses of occurrences beyond the edge of sight, perhaps as an adaptive necessity (sensing the approach of something dangerous), but also as the source of the desire to always know more than we can see, without which we are doomed to forgo personal or social evolution. This more than anything is the subject of the paintings in *Chaos and Awe*. With their shifting perspectives and fragmentation, qualities of instability and murkiness, these paintings enclose that which Morley notes is "wholly unenclosable."

Works in *Chaos and Awe* describe this plastic frontier in the language of emotion, with gestures, smears, fragments, and amorphous fields providing visual equivalents of fear, anxiety, or excitation at picturing a slice of the unknown. The exhibition starts with a negative pole in the section "No Place," featuring paintings by Franz Ackermann, Peter Halley, and Sue Williams that denote interconnected forces shaping contemporary global experience in ways that are powerful, insidious, and for most people, impenetrable. Their visions of a floating *theatrum mundi* are given an acute historical backdrop in the following section, "Shadows," with works by Radcliffe Bailey, Jeremy Blake, Dean Byington, Nogah Engler, Ellen Gallagher, Rashid Johnson, and Neo Rauch, and again in "Collisions," with works by Ahmed Alsoudani, Ali Banisadr, and Rokni Haerizadeh. These artists allude through semiabstract languages to long-term conflicts as they continue to be played out in mechanisms of racism, nationalism, and religious or ideological extremism.

In her essay in this catalog, art historian Media Farzin discusses the representation of humanity not as individuals, but as masses and multitudes that have been set in motion by broad social and historical forces beyond their control. Farzin proposes that certain works embody "a cosmopolitan practice of painting"—snapshots of the sociopolitical transformations of a contemporary world where communities are

defined not by what they share (nationality, race, ethnicity), but by their movements, their traumas, their felt sensations and lived experiences.

Farzin considers the Western tradition of history painting, with its goal of edifying a populace about its ideals and heroes, to be a manifestation of the desire to create a cohesive national identity. To define the history of this century, such an approach would require turning a blind eye to the contingent conditions of society. Thomas McEvilley writes, "Cultures only really believe in themselves while they remain isolated. With contact, they cannot avoid relativization. Nowadays, communications technology acts as the handmaiden or facilitator of postcolonial encounters, which inevitably lead to a relativization of the values and feelings of the cultures involved."[7] The feeling of anxiety conveyed in "Shadows" and "Collisions" stems from the realization that the singular worldviews that predate this relativization remain in play, and in truth may today be growing in strength and divisive intent.

The progressive entanglement of cosmopolitanism is the subject of the section "Interzone," in which dramatic cultural encounters are shown as forming a new social imaginary, defined by swings between toxic potentiation and pleasure.[8] Paintings by Ghada Amer, Eddy Kamuanga Ilunga, Jiha Moon, and Wangechi Mutu explore mergers of gender and sexuality, ideologies and customs, and other aspects of cultural identity. Note the integration of Bart and Marge Simpson's hair and the Microsoft butterfly logo with "natural" butterflies in the detail of Korean artist Jiha Moon's *Springfield—Butterfly Dream* (2010; figure 0.4). Artists in this section transform cultural dissonance into overgrown gardens in which entropy and fragmentation provide the fertilizer for surprising new aesthetic organisms.

In the digital era, the anarchy of infinite possibility, as well as the radical questioning of any data that do not conform to one's own views, have forged a widespread perception that the threshold between knowledge and doubt is uncrossable, which has inadvertently inserted a sense of sublimity into everyday life. With the section titled "Virtuality," the exhibition moves from geographic and cultural interfaces to expressions of this liminal conundrum. In paintings by Korakrit Arunanondchai, Wayne Gonzales, Wade Guyton, and Corinne Wasmuht, and a painting-like virtual reality work by Rachel Rossin, solidity melts away and space and time hover between the unfixed and the concrete. The natural heir to painting's inherently virtual space, digital imagery is an illumination without authority, a thought balloon floating anchorless in the world. If nothing else, paintings in this section bring such imagery back to the physical, through handmade process, monumental scale, and the tactility of the medium itself.

"Virtuality" segues smoothly into "The Boundless," a section that includes works by Matti Braun, Hamlett Dobbins, Barnaby Furnas, Heather Gwen Martin, Julie Mehretu, James Perrin, Pat Steir, Barbara Takenaga, and Charline von Heyl that

portray various phenomena—floating forms, atmosphere, liquid, gas, flame, and light—as signs of the elusive nature of perception. These abstract paintings relate to the sublime in terms of vagueness and lack of solidity, offering a compelling obscurity that links the indeterminate nature of the mind with the vastness of the universe. Precedent is found in the stormy atmospheres depicted by J. M. W. Turner, in which paint's provisional qualities are ideally suited to finding in the de-substantiation of the external something of the ephemerality of the internal. In 20th-century American art, this ecstatic sublimity was recast into expressions of existentialism, mixing despair and enlightenment in a turn to the void. Tragedy is invoked in Barnett Newman's undifferentiated fields of color, bisected by stripes or "zips" that signify the fragile beam of spiritual aspiration, animating emptiness with a narrow glimmer of potential meaning. In works by Turner and Newman, as with those by Furnas, Perrin (figure 0.5), Steir, and the others in this section, color, form, and atmosphere wash over and absorb viewers, bringing them to an experience of psychological and spiritual expansiveness through the phenomenal effects of paint alone.

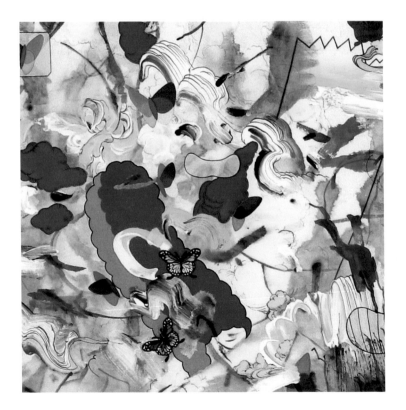

0.4 Jiha Moon, *Springfield—Butterfly Dream* (detail), 2010.

0.5 James Perrin, *Semiosis on the Sea* (detail), 2015.

The exhibition concludes with paintings that define a passage from unformed potentiality to speculative visions of consciousness, moving us from uncertainty toward awe. In her speech accompanying her acceptance of the 1996 Nobel Prize in Literature, Wisława Szymborska elaborates on the psychic value of unknowability:

The world—whatever we might think when terrified by its vastness and our own impotence, or embittered by its indifference to individual suffering, of people, animals, and perhaps even plants . . . whatever we might think of this measureless theater to which we've got reserved tickets, but tickets whose lifespan is laughably short, bounded as it is by two arbitrary dates; whatever else we might think of this world—it is astonishing.[9]

The concluding section of the exhibition, "Everything," includes works by Pedro Barbeito, Anoka Faruqee, Guillermo Kuitca, Matthew Ritchie (figure 0.6), Dannielle Tegeder, Kazuki Umezawa, and Sarah Walker. These artists shuffle the social imaginary together with the irrational and speculative dimensions of the mind to propose a widening gyre that even takes chaos into account. In his dizzying essay "A Gate, a Key, an Ocean," in this catalog, Matthew Ritchie writes of the universe as a "radiant

abyss," any representation of which "must reflect our understanding that 'it' (by which I mean 'everything') is present, both within us and without." Artists, Ritchie suggests, are equipped to rise to the challenge of answering the question "How do we picture these new invisible presences, occupying what we previously understood as the very definition of absence?" Reinforcing the thread that runs through this exhibition, Ritchie argues that boundaries between the mind and the cosmos, real and unreal, internal and external, even present and future, are fluid. Theories about the connected operations of the universe might provide a model for our conceptualization of society, "framing how we understand and operate in an increasingly shared world."

Integrating interests from mathematics and cosmology to science fiction and philosophy, the works in "Everything" defy the impulse to allow fear of the unknown to lead us increasingly inward or backward. But even in this part of the exhibition, a virus remains visible in the form of glitches, tumorlike blots, and systemic irregularities—contaminants that signal human error and pathological agency, the endless potential for entropy and even disaster. As humanity comes closer to understanding its myriad systems, banks of knowledge, and psychological and biological identities, will it be able to fold its own corruption into a theory of everything? This question brings the viewers full circle back to the darkness of "No Place," where they began.

0.6 Matthew Ritchie, *A bridge, a gate, an ocean* (detail), 2014.

Notes

Epigraphs: W. J. T. Mitchell, "World Pictures: Globalization and Visual Culture," in *Globalization and Contemporary Art*, edited by Jonathan Harris (West Sussex, UK: Wiley-Blackwell, 2011), 253. Alberto Ruiz de Samaniego, "In This Time of Phantoms," in *The Unhomely: Phantom Scenes in Global Society*, edited by Okwui Enwezor (Seville: Fundación Bienal Internacional de Arte Contemporáneo de Sevilla, 2006), 105.

1. Jacques Henric, "The Sublime, as Love, 'a la Colle,'" in *Sticky Sublime*, edited by Bill Beckley (New York: Allworth Press, 2001), 100.

2. Zygmunt Bauman, *Liquid Life* (Cambridge: Polity Press, 2005), 3.

3. Edmund Burke, *A Philosophical Enquiry into the Origins of Our Ideas of the Sublime and Beautiful*, edited by Adam Phillips (Oxford: Oxford University Press, 1990), 36.

4. Philip Shaw, *The Sublime* (Abingdon, UK: Routledge, 2006), 3.

5. Jeremy Gilbert-Rolfe, "I'm Not Sure It Is Sticky," in Beckley, *Sticky Sublime*, 93.

6. Caroline A. Jones, "Fields of Intuition (in Four Proportions and Five Mods)," in *Remote Viewing: Invented Worlds in Recent Painting and Drawing*, edited by Elisabeth Sussman (New York: Whitney Museum of American Art, 2005), 81–82.

7. Thomas McEvilley, "Turned Upside Down and Torn Apart," in Beckley, *Sticky Sublime*, 78.

8. *Interzone* is also the title of a book by William S. Burroughs which tells stories of the Tangier International Zone, where characters of all manner, nature, and foible commingled, laws and conventions were flexible, sexual behavior in all its permutations was not discreet, and the liberation of the senses through drug use was normal; a place where, to use the aphorism of the assassin Hassan-i Sabbah (quoted by Burroughs and many others), "nothing is true, everything is permitted."

9. Wisława Szymborska, "Nobel Lecture—The Poet and the World," December 7, 1996, http://www.nobelprize.org/nobel_prizes/literature/laureates/1996/szymborska-lecture.html.

MEDIA FARZIN

On Scale

History painting has always made me feel small. There's a Giuseppe Castiglione painting of the Louvre that captures exactly how I feel there. *The Salon Carré at the Musée du Louvre* (1861; figure 1.1) shows the great hall on a busy day. A soft light glints off the vaulted ceilings, leading the eye down to paintings that are hung—salon-style, naturally—all the way to the floor. Visitors wander about, chat in pairs, or read stiffly on the plush ottoman. In one corner, a young woman paints at a sturdy-looking easel.

I always identify—as I'm likely supposed to—with the two fellows on the lower right who stand with their backs to us. Their costumes are sprightly, sketched out in blobs of paint: blue hooded capes over red uniforms that contrast with their bright white spats. I don't know who they are, but they look *foreign*. Different. Their pants are billowy and their hats just might be turbans.[1]

They also look really, really small. They're tiny foreigners dwarfed by the immensity of the salon, the volume of its stuff, and even by the painted subjects of the canvases they admire. We, with our god's-eye view of the whole room, have a much better view of most of the paintings than they would. But they're certainly animated, with one pointing out to the other a vaguely limned but majestic Madonna.

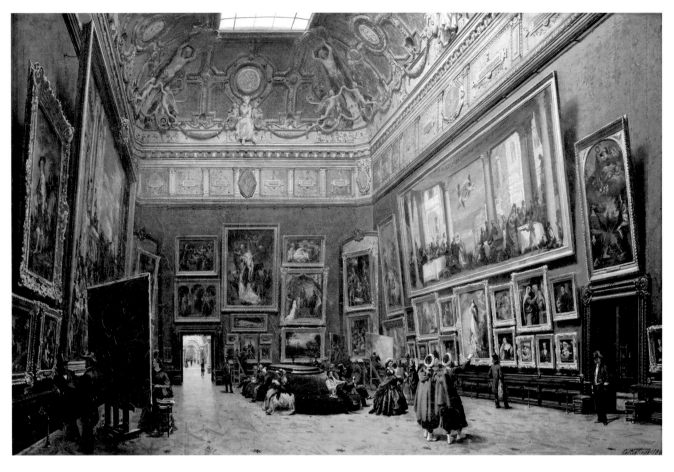

1.1 Giuseppe Castiglione, *The Salon Carré at the Musée du Louvre*, 1861.

Most history paintings make me feel like this. When I first saw Théodore Géricault's *Raft of the Medusa* (1818–19), it was all stormy sea and bloated limbs. Jacques-Louis David's *Oath of the Horatii* (1784; figure 1.2) was mostly monumental toes. At least his *Intervention of the Sabine Women* (1799) had the pathos of the children about to be trampled underfoot, their palpable vulnerability accessible at eye level.

It wasn't just that I was standing too close. (For, how else to bridge the distance of endless reproductions, to bask in their aura?) I was frustrated by the invisible barrier of decorum and the hectoring tone of edification. I was held back by the clarity of the history on view—a dignified and implacable tale in which you are either with us or . . . outside, other, elsewhere, *below*.

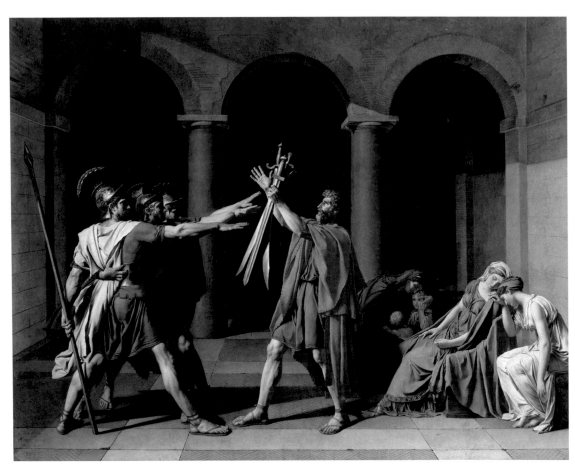

1.2 Jacques-Louis David, *The Oath of the Horatii*, ca. 1784.

The Castiglione painting is relatively small: it's maybe two or three feet high, not counting the impressive gilt frame. It's not intended as a history painting; it's merely a charming scene in the genre of "A day at the galleries," and a precise document of its location, down to the identifiable paintings on view that year.

But it's also a fine demonstration of history painting's key qualities. Its story—the history of Western art—is rendered with heroes in period garb, a familiar setting, and a momentous event: the idealized encounter between audience and artwork. The barbarians are educated, a young woman learns from her masters, and culture's civilizing mission prevails. That the protagonists are far from life-size—unlike those in traditional history painting—is, for my purposes here, entirely the point.

"Your Paintings Are Nothing Like Arab Paintings"

In 2014, a contributor to *Al-Monitor*, an online news site with a Middle Eastern focus, sat down for a Q & A with the U.S.-based Iraqi artist Ahmed Alsoudani, who had just opened his first solo show with New York's Gladstone Gallery. The interviewer quickly got to the point: "Your paintings are nothing like Arab paintings—what makes them special?"

Alsoudani, who moved to the United States in his early twenties, has enjoyed increasing market success, and his interlocutor was most likely expressing his admiring curiosity. The painter, in any case, handled it gracefully: "My topics are inspired from the Eastern culture and my tools and visual language are derived from the West."[2]

The interviewer's artless question revealed a common perception about artists from "elsewhere"—that to achieve success in the Western art market, they need a recognizable style or tribal belonging: something like a visible artistic "Arabness." But Alsoudani's personal history and memories are central to his paintings. His large-scale canvases show masses of bodies and objects, with limbs and utensils and patterns and colors roiled into complex volumes. He deals in pain and torture, working within the political lineage of Max Beckmann and the figurative legacy of Francis Bacon.

"My figures are intentionally ambiguous," Alsoudani has said. "I do not feel it is necessary to graphically delineate torture; just suggesting it is enough."[3] The suggestion is accomplished through the visceral violence of his contrasts, which register pressures and effects that lie outside the canvas. His figures quite often look like trash—like things damaged, discarded, and washed up with jetsam—and yet paradoxically pulse with the internal force of the composition (figure 1.3).

Surrealism is important to many Middle Eastern modernities, as a valuable model for expressing historic truths that exceed representation, at least in the rational languages of Western art. The legacy of Salvador Dalí, André Breton, and Man Ray taught many an artist (and writer) to express darkness through juxtaposition and distortion. Perhaps this is the Arabness that Alsoudani's interlocutor wanted to explore—the surreal, visceral world that pulls the viewer into its political undertow.

On Space

History painting was founded on the stories of great men. In David's *Oath of the Horatii*, the men's heroic strength is all the more forceful for its contrast with the distraught postures of the women and children. Joshua Reynolds, theorizing about the style in the 1770s, cautioned that "there must be something either in the action, or in the object, in which men are universally concerned, and which powerfully strikes

1.3 Ahmed Alsoudani, *Birds*, 2015.

upon the publick sympathy."[4] In other words, the more we care about the people in a story, the more we want to hear the story.

So, the figures in these paintings were designed to be very large—life-size or larger, when circumstances allowed—and rendered in bold colors, with period costumes that could evoke familiar times and places. The towering Horatii invite the viewer into their neoclassical space to share the thrilling fearsomeness of the battle to come. David's ancient Rome is essentially 1780s France in fancy dress—a place where good men make hard choices and sacrifice their personal comforts for larger social gains.

History painting, the late artist and writer Jon Thompson once said, was very much an art of *place*: its sense of history was bound up in its depiction of classical locales. Past and present were connected by an easy, unbroken timeline anchored to a (nationally) bounded space. Is history painting still possible, Thompson wondered, given all that has changed since David's day? Thompson asked: "Can it survive the death of history as a grand narrative? Can it survive the fragmenting forces of contemporary constructions of time and space? Can it be divorced from the epic? Can it be unpeopled?"[5]

I like Thompson's idea of an "unpeopled" history. The art historian T. J. Clark saw a similar preoccupation in the mediated compositions of Gustave Courbet and Édouard Manet. Others have read historic ambitions in the panoramic photographs of Jeff Wall and the monumentalizing paintings of Gerhard Richter, where figures appear against hazily outlined grounds that lack geographic specificity—against mere space, rather than Place. As for the viewer joining the erstwhile heroes, both Wall (say, in his 1992 *Dead Troops Talk*) and Richter (in his 1988 *October* cycle) give us protagonists who are distinctly, and rather unheroically, dead.[6]

It is this contemporary ambiguity that I wish for, when I stand, as alienated and admiring as a Zouave, before a David canvas. And it is this acknowledgment of space that I find in the torqued flows and unlocalized violence of Alsoudani's paintings. Such spaces speak of histories that lack any clarity—of everyday heroism and perplexing political dilemmas, and stories that are unfolding as they are being painted.

Images That Go Straight to Your Brain

The Romanian artist Adrian Ghenie has made several paintings about a particular event: a rainy evening in 1933 when a crowd of students gathered in the large public square in front of Berlin's Humboldt University to burn piles of "un-German" books (figure 1.4). Some of the paintings show the event from above, with flickers of color rising from the smolders; others show figures approaching the fire with their contributions, their bloblike faces expressionless.

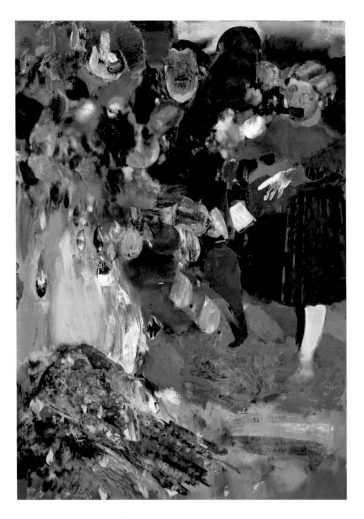

1.4 Adrian Ghenie, *Burning Books*, 2014.

Ghenie's many portraits are often characterized by their subjects' smudged and smeared faces (figure 1.5). In his "pie fight studies," unrecognizable figures claw at the paint that thickly and comically covers their faces. But his Adolf Hitler, Josef Mengele, and Charles Darwin remain recognizable despite their ruined features. Ghenie searches for his images online, choosing the most familiar and clichéd of sources and channeling the most common of collective memories, the better to stage his obliterating manipulations.

"I seek images that go straight to your brain, which you can't help but submit to," Ghenie has said.[7] He paints history, but he seeks a subjective impact. Figuration, in

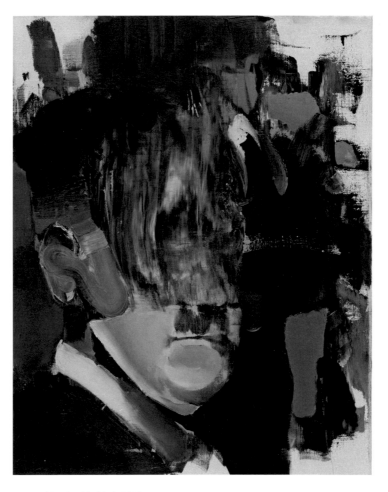

1.5 Adrian Ghenie, *Untitled*, 2012.

his paintings, always feels cinematic, his spaces invoking a photographic depth of field that is interrupted by splotches of color. The work portrays a space suspended between the past—of personal memory as well as collective history—and the here-and-now of the canvas.

Ghenie paints the spectrum of violence inflicted on bodies and objects. These images may address the brain, but their conduit is the body. Gilles Deleuze, writing about Francis Bacon (a painter important to both Alsoudani and Ghenie), called this a "violence of a sensation."[8] Bacon's deformations of figure, color, and line, he argued, stage a violence that is separated from the act of representation but remains within the realm of the figure.

The response such an approach invites is very different from the ethical demands of a direct representation of violence. "What is painted on the canvas is the body, not

insofar as it is represented as an object, but insofar as it is experienced as sustaining *this* sensation," Deleuze writes.[9] Hovering in an ambiguous space of abstraction and distortion, the figure invites a felt, sensory identification with its attendant traumas.

Ghenie's layers of violent sensation usually speak of known historic events. But in a marked contrast to David's dramatic clarity, Ghenie's event-space is vague, face-less, and hero-less. There are only the culpable, the victims, and the space they occupy together. I think of the young female painter in the Castiglione gallery scene. If I squint hard at the painting's cracked surface, her tiny face dissolves into a blob of beige paint—no mouth, no eyes.

On Movement

To speak analytically about history painting, we first need to identify the values and aspirations of the makers, their audience, and the history that they share. This is no easy task today: placing patriotic ideals before personal comforts, as the Horatii did, would be meaningless to those who have lost their *patria* and never had much by way of personal comfort.

Can history painting be unpeopled? Can it allow for the stories of migrants, for example, who are defined by their movement? Refugees of global upheavals (of ideology, climate, or capital) are perpetually in transit, their values caught in the limbos

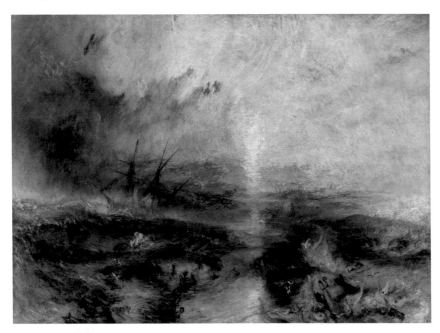

1.6 J. M. W. Turner, *Slave Ship* (*Slavers Throwing Overboard the Dead and Dying, Typhoon Coming On*), 1840.

of statelessness and border rifts. Their story—a vast and faceless global crisis—demands accounting to the very extent that it defies clear narratives.

The artist and writer Hito Steyerl has looked to J. M. W. Turner's *Slave Ship* (1840; figure 1.6) as a paradigmatic image for Western history—one of its earliest depictions of history-from-below. It's based on a violent story: the captain of a slave ship, realizing that he can claim insurance only on slaves "lost at sea," has the dead and dying thrown overboard. Turner's rendition is remarkably bloodless, with most of the canvas given over to a textured orange sky and a turbulent golden sea that, upon close scrutiny, turns out to be dotted with tiny, bobbing hands.

Stare at it long enough, and *Slave Ship* can make you seasick. "The observer has lost his stable position," Steyerl points out, and is "upset, displaced, beside himself at the sight of the slaves, who are not only sinking but have also had their bodies reduced to fragments—their limbs devoured by sharks, mere shapes below the water surface."[10] Turner's abstraction has distorted the very principles of linear perspective, reframing colonial power through a painted violence of sensation.

Ellen Gallagher's *An Experiment of Unusual Opportunity* (2008; figure 1.7) refuses conventional narrative altogether. Its subject, the artist has said, is the Tuskegee Experiment, which gathered hundreds of black American men suffering from syphilis for a government-run study. Treatment was withheld from them for decades while scientists studied the progress of the disease.

Gallagher's canvas, covered with collaged striations, shows a dark undersea world: I can make out a patterned squid, perhaps an eel, and hints of octopus limbs that seem to billow and bloom. It's a deliberately secretive canvas, menacing and sensual in equal measures, and it withholds information from the viewer, just as information was withheld from the experiment's six hundred subjects. There are no people, no horizon line, and no story—everything is slippery movement.

A Multitude on the Verge

Ali Banisadr paints swarms. While his recent canvases have focused on larger figures, they, like most of his work, present vibrant, carnivalesque scenes that, from a distance, appear to be made up of countless moving figures. But, up close, his figures dissolve into abstract swirls of color and texture (figure 1.8).

Banisadr describes them as paintings "on the verge"—deliberately positioned in an indeterminate zone between abstraction and figuration. "They don't want to take responsibility and stand for something," he explains. "It is about dealing with the conflict of thoughts in your mind and reaction to what is happening in the world now and historically . . . to try to understand the world in a visual way."[11]

His work has drawn comparisons with the apocalyptic landscapes of Hieronymus Bosch and the extravagantly detailed surfaces of Persian miniature painting. From

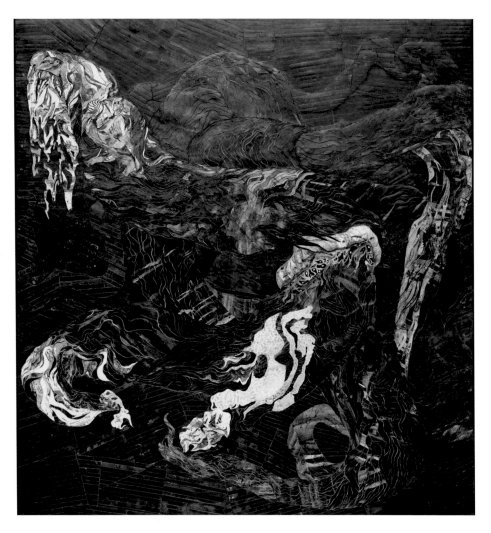

1.7 Ellen Gallagher, *An Experiment of Unusual Opportunity*, 2008.

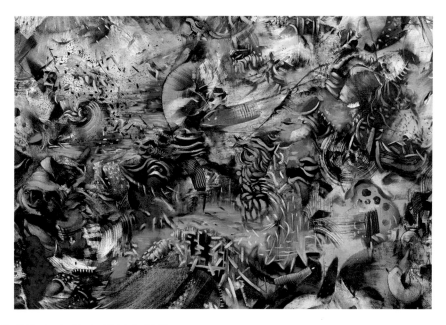

1.8 Ali Banisadr, *Contact* (detail), 2013.

Bosch, he has borrowed a sense of cosmic drama; from the likes of the 15th-century Safavid painter Bihzad, a compositional dynamism of static figures. His work also reveals what certain strains of Northern Renaissance art share with Islamic painting: the ability to keep the eye in perpetual motion.

I've always felt that the Iranian-born painter's multitudes echo the creative force foregrounded in Michael Hardt and Antonio Negri's *Empire* (2000). Their book is a visionary work of political philosophy, in which they describe a multitude "capable of autonomously constructing a counter-Empire, an alternative political organization of global flows and exchanges."[12] Banisadr's canvases on-the-verge hint at the dual nature of Empire's multitude: defined by movement, they are simultaneously reactive and creative.

For a multitude to realize their creative power, Hardt and Negri believe, their actions must become political: to demand global citizenship, for example, so that migrants might one day control their own movements. But politicization requires, as a first step, the multitude's awareness of its breadth and potential. It requires an *image* of multitude, in all its sprawling abstraction—an image that can move between space and place, past and present, mass and detail.

On Bodies

History painting started as a cerebral art. Renaissance painters, wanting to be acknowledged as intellectuals and free men, came up with an elaborate theory of painting that paralleled that of rhetoric or grammar. It was a bid for respect, pitched to a new class of educated patron with an interest in ancient history. But its ultimate goal was sensory impact, through highly thought-out compositions that would reveal themselves "to be so charming and attractive as to hold the eye of the learned and the unlearned spectator for a long while with a certain sense of pleasure and emotion."[13]

Pleasure is a key element in Rokni Haerizadeh's practice, as is the artist's role as an intellectual. The Dubai-based Iranian painter has, since 2009, created collages and animations using stills from news media. His "moving paintings" turn arrests, rallies, and press conferences into strange bestiaries, doodling a snout or donkey ears here, gangs of cats and mice there, and interspersing parrots giving military salutes amid headless bodies and floating mouths. And it's no coincidence that "pig" and "ass" are slurs in Farsi.

Haerizadeh's exaggerations bring out the savagery of the actions they depict, highlighting the bestial undertones of political rituals. Victim and aggressor are equally grotesque, as are landscapes and architecture. The result is a baroque sense of profusion that would have pleased many a Renaissance art theorist. "The first thing that gives pleasure in a *historia* is copiousness," the artist and theorist Leon Battista Alberti wrote. "I would say a picture was most copious if it contained a mixture of old men, youths, boys, matrons, maidens, children, domestic animals, dogs, birds, horses, sheep, buildings, and provinces."

Haerizadeh is building on a long literary tradition of using animals to talk about darker human truths. Most Iranians are familiar with the *Panchatantra*, a collection of Sanskrit fables dating to the 3rd century BCE, through its later Persian translation known as *Kalileh va Demneh*. And George Orwell's dystopian 1945 novel *Animal Farm* is nearly as popular as *Shahr-e-Ghesse* (*City of Tales*), a 1968 play by the Iranian director and actor Bijan Mofid. Mofid's highly politicized example of musical theater, which was ostensibly written for children and became one of the most beloved productions in Iranian theater history, gave Haerizadeh the title of his first series of collaged paintings, the 2009 *Fictionville*.

There are strong resonances between the humorous, singsong verses of Mofid's play and the playful distortions of Haerizadeh's collages. Both are attuned to bodily rhythms, both borrow from familiar sources and languages, and both harbor a sharp critical edge that cuts beyond current events or political party lines. Such work can be disarmingly appealing in its sensory recasting of familiar places and events. The immediacy of the painted imagery creates a bodily connection between the artist and

the viewer, allowing us not only to witness but to experience with him the violence of sensation.

Cosmopolitan Figurations

One of Haerizadeh's more recent projects on paper is *My Heart Is Not Here, My Heart's in The Highlands, Chasing The Deers* (2013; figure 1.9), a group of twenty-four drawings. The settings are highly varied, covering the Libyan uprising, a Pussy Riot performance in Moscow, and the British royal wedding of Kate and William. There are churches, ruins, checkpoints, a shipwreck, and a protest that features a lion-tiger hybrid holding a sign that says, "I'm gay, Nigerian, and real."

1.9 Rokni Haerizadeh, *My Heart Is Not Here, My Heart's in The Highlands, Chasing The Deers*, 2013.

The project's title comes from a patriotic lament by the Scottish poet Robert Burns. The voice—that of a Highlander in exile—is perhaps speaking for many driven off the land they had farmed as tenants after 18th-century land reforms:

My heart's in the Highlands, my heart is not here;
My heart's in the Highlands a-chasing the deer. . . .
Farewell to the Highlands, farewell to the North,
The birth-place of Valour, the country of Worth.

Patriotism seems far from Haerizadeh's project. I would have suspected the title of irony, if much of the artist's work didn't convey a sincere and persistent engagement with his own homeland, which he and his brother were forced to leave in 2009. I find myself drawn to the layered cosmopolitanism of *My Heart Is Not Here*, in which an Iranian poetic sensibility is grafted onto a Scottish romantic folk song that is itself a borrowing of a regional style. The campy emotional melancholy of the phrase turns out to be at home in both cultures.

For political theorists, cosmopolitanism can be a hard sell. Patriotism is immediate and felt (as David well knew), while cosmopolitanism—the notion of being, like the Greek philosopher Diogenes, "a citizen of the world"—sounds not only vague and foreign, but impractical as well. As Martha Nussbaum muses (commenting on a novel by the Indian author Rabindranath Tagore), "Patriotism is full of color and intensity and passion, whereas cosmopolitanism seems to have a hard time gripping the imagination."[14] Kwame Anthony Appiah agrees, reminding us that the Liberian writer Edward Blyden once called patriotism "the poetry of politics."[15]

But Appiah hopes that, at its best, a cosmopolitan worldview can introduce the notion of difference into politics, while keeping the poetic hold, and concreteness, of the idea of belonging. If patriotism is a feeling that is mainly related to the people with whom we are connected, then "it is the connection and the sentiment that matter," Appiah writes, "and there is no reason to suppose that everybody in this complex, ever-mutating world will find their affinities and their passions focused on a single place."

It's a theory that David would have dismissed out of hand. The Horatii men vow to go to war precisely because they believe that affinities should be bound to a single place. But the more we learn about the vast numbers left out of that conception of place—basically everyone but the sword-wielding, land-owning men—the less tenable its vernacular becomes. The timeline of history has splintered into multiple histories. Its decorum feels suspect, and its great men, dangerous. Multitudes are milling in our midst, with countless stories to tell. The stories are usually violent. The violence is most often senseless. And, sadly, cosmopolitanism, as a politics, seems less sustainable than ever before.

This is where aesthetics—contemporary experiments in figuration, in particular—might have something more concrete to offer. Abstraction, deformation, the violence of sensation, movement, bodily presence, witnessing, humor, and play can bring intensity and passion into a cosmopolitan practice of painting—one that is defined by difference, not as a principle or a theory, but simply as part of the lived experience of its practitioners. Such images can open up the ambiguous spaces and values of our present moment, conveying its conflict and chaos through sensation. That this will often involve tiny, faceless, nameless, and unheroic bodies—animals and hybrids and imagery that defies recognition—is precisely the point. This is the image of history painting unpeopled.

Notes

1. The men are, I later learned, outfitted as Zouaves, soldiers in the French infantry. Their regiment had started out as the French imperial army's first multicultural cohort, with a contingent of North African volunteers who were nomadic Arabs of the Zwawa tribe. The Zouaves are foreigners twice over: in the nation and in the museum.

2. Shukur Khilkhal, interview with Ahmed Alsoudani, "Iraqi Artist's Work Spans East, West," *Al-Monitor: The Pulse of the Middle East*, December 1, 2014, http://www.al-monitor.com/pulse/originals/2014/11/iraq-artist-paintings-wolrd-museums.html.

3. Robert Hobbs, interview with Ahmed Alsoudani, in *The World Belongs to You*, edited by Caroline Bourgeois (Milan: Electa, 2011), 41.

4. Joshua Reynolds, *Discourses on Painting and the Fine Arts, Delivered at the Royal Academy* (London: Edward Lumley, 1850), 17.

5. Jon Thompson, "Painting Present: History Painting," lecture at the Tate Modern, February 18, 2013, http://www.tate.org.uk/context-comment/video/painting-present-history-painting.

6. See T. J. Clark, *Image of the People: Gustave Courbet and the 1848 Revolution* (London: Thames and Hudson, 1973); T. J. Clark, *The Painting of Modern Life: Paris in the Art of Manet and His Followers* (Princeton, NJ: Princeton University Press, 1984); and David Green and Peter Seddon, editors, *History Painting Reassessed: The Representation of History in Contemporary Art* (Manchester, UK: Manchester University Press, 2000).

7. Stephen Riolo, "Adrian Ghenie, Pie Eater," *Art in America*, October 26, 2010, http://www.artinamericamagazine.com/news-features/interviews/adrian-ghenie.

8. Gilles Deleuze, *Francis Bacon: The Logic of Sensation*, translated by Daniel Smith (London: Continuum, 2003), 82.

9. Ibid., 35.

10. Hito Steyerl, "In Free Fall: A Thought Experiment on Vertical Perspective," *e-flux journal*, no. 24 (April 2011), http://www.e-flux.com/journal/24/67860/in-free-fall-a-thought-experiment-on-vertical-perspective.

11. Ali Banisadr in conversation with Boris Groys, *Ali Banisadr: One Hundred and Twenty-Five Paintings* (London: Blain|Southern, 2015), 25.

12. Michael Hardt and Antonio Negri, *Empire* (Cambridge, MA: Harvard University Press, 2000), xv.

13. Leon Battista Alberti, *On Painting and Sculpture: The Latin Texts of "De Pictura" and "De Statua"* (1435), edited and translated by C. Grayson (London: Phaidon, 1972), 68.

14. Martha C. Nussbaum, "Cosmopolitanism and Patriotism," *Boston Review* (October 1, 1994), http://bostonreview.net/martha-nussbaum-patriotism-and-cosmopolitanism.

15. Kwame Anthony Appiah, "Cosmopolitan Patriots," *Critical Inquiry* 23, no. 3 (Spring 1997): 622.

2 THE BRAIN IS WIDER THAN THE SKY

SIMON MORLEY

The brain is wider than the sky,
For, put them side by side,
The one the other will include.

EMILY DICKINSON

Today, ancient wisdom and the latest science seem to have reached the same amazing conclusion: the walls around reality are porous and open to infinite transformations. At the same time, the unlimited traversability of cyberspace has added a massively alluring new dimension to life, one in which the normal balance between our senses and our subjectivity is permanently destabilized. Indeed, the fact that we are now living with and in the new digital media means we can shake off the limitations imposed by material reality and bodily existence. In this accelerated virtuality, the temptation to ignore our physical constraints can become overwhelming. We live in a new kind of reality, where the biological and the technological merge to produce a "post human" ecology. This situation compels artists to push beyond the old

cognitive, semantic, and formal categories on which art has depended since the humanist worldview emerged in the Renaissance. As participating artist Matthew Ritchie declares, "The universe is an infinitely radiant abyss, eternally emitting information on every frequency. Facing such a comprehensive reordering of our proprioceptive limits, we need to reset our perceptual frameworks at every level."[1]

What is the role of painting within this unprecedented situation? To many, it seems to lack the qualities necessary to be a truly *contemporary* medium. Painting's overtly framed format and its finite materiality have increasingly been seen as a limitation, and artists seek less constraining means to engage with such a new reality. Painting, it is said, is just too embedded in conventions that depend on outmoded ideas and concepts, and has little value beyond the marketplace.

In relation to these criticisms, two characteristics of painting are especially significant: the *frame* and the *surface*. All forms of art must have a frame, as through creating a clearly defined format, they work to distance us from the flux of reality. "To be truly artistic," writes the philosopher John Dewey, "a work must also be esthetic—that is, framed for enjoyed receptive perception."[2] But some frames are more obvious and longer enduring than others, and those possessed by paintings are especially historical and perceptually obvious. They can be likened to other human-made and geometrically shaped two-dimensional formats, such as a book page or a map, or vertical surfaces, like a wall or a notice-board. But we also tend to see *into* such vertical surfaces, and as a result, an illusionistic or virtual dimension will often suggest itself; and then a painting's frame has obvious analogies to similarly framed-off spaces to be found in the real world, such as windows, doorways, arches, tunnels, and theatrical stages. Today, however, another obvious analogy presents itself: the screen. This is an especially powerful kind of format. As Gilles Deleuze writes:

In the final analysis, the screen, as the frame of frames, gives a common standard of measurement to things which do not have one—long shots of countryside and close-ups of the face, an astronomical system and a single drop of water—parts which do not have the same denominator of distance, relief or light. In all these senses the frame ensures a deterritorialisation of the image.[3]

Not surprisingly, paintings in the era of the LED-backlit computer and smartphone often engage with the kind of spaces and effects that the electronic screen generates. As a result, many paintings today seem to be hybrid constructions, bringing together maps, diagrams, windows, movie and computer screens, abstract constellations of information, and the chaotic randomness of garbage dumps. In *Chaos and Awe*, this contemporary "deterritorialisation of the image" is perhaps most obviously epitomized by Franz Ackermann's *Untitled (yet)* (2008–9; figure 2.1), but many of the works in the exhibition suggest such hybrid and deliberately excessive characteristics.

But the materiality of a painting's surface nevertheless holds it firmly within the analog realm of the handmade, and this concrete plasticity is an especially obdurately

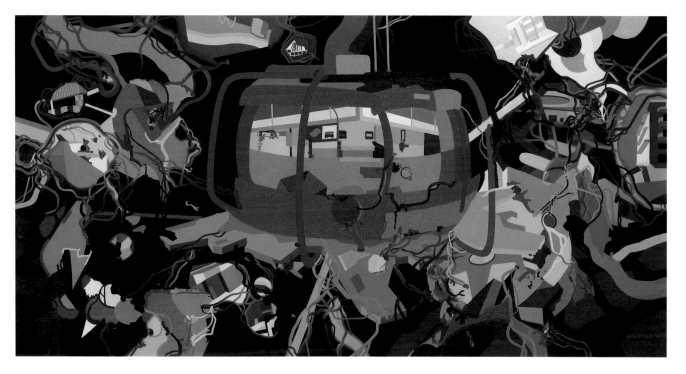

2.1 Franz Ackermann, *Untitled (yet)*, 2008–9.

present ingredient of any encounter. Paint pigment—the traces that have been left on the painting's surface through manual brushwork activity—make a connection to the body that once deposited these traces on the two-dimensional surface. A painting's surface is a record of a series of manual actions, and is thus very different from the smooth, mechanically produced surfaces of digital screen technology, which are merely electronically generated. This viscous substantiality, combined with the geometric frame, serves to make painting stand out not only from real-life situations, but also from other visualizing media.

Given the overt dynamism and shifting and unstable perspectives, many of the works in *Chaos and Awe* convey the sense that the frame is only a temporary or contingent act of enclosing something much greater and fundamentally unenclosable. The art historian Heinrich Wölfflin noted in his *Principles of Art History* (1915) that the rectangular framing edge can function in two ways. It can serve as the limiting boundary to what is contained within—in which case, the painting is what he termed a "closed" work, as in an example of a 17th-century Dutch still life by Ambrosius Bosschaert the Elder (figure 2.2). Or the framing edge can suggest that what is contained within the frame can notionally be continued to a greater or lesser extent beyond the edges, as in this painting by J. M. W. Turner (figure 2.3).[4] In *Chaos and Awe*, the "open" frame is certainly the one most often deployed.

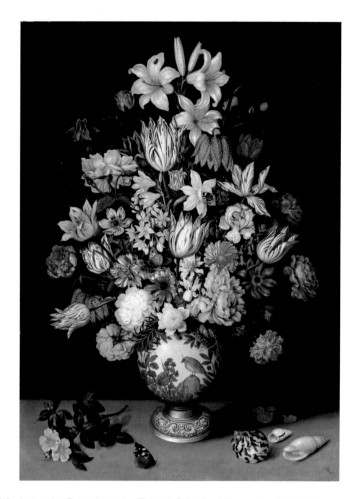

2.2 Ambrosius Bosschaert the Elder, *A Still Life of Flowers in a Wan-Li Vase on a Ledge with Further Flowers, Shells and a Butterfly*, 1609–10.

The paintings in this exhibition are indeed restless and vertiginous. There is much evidence of dynamic and formless brushstrokes, producing a sense of perceptual fluidity or indistinctness (Matti Braun, Barnaby Furnas, Julie Mehretu). There are complex, multilayered organizations of the pictorial field (Ackermann, Dannielle Tegeder). Many of the paintings generate networks of nongeometric forms, involving richly contrastive clashing colors, which challenge our ability to organize what we see into stable patterns (Korakrit Arunanondchai, Ellen Gallagher, Jiha Moon). We see the deliberate courting of visual obscurity, often to evoke the turbulent and indecipherable world that we sense lies just below the surface of "normal," ordered social reality (Ali Banisadr, Matthew Ritchie, Sue Williams). Many of the works lack visual focal points and blur contours in order to convey the untamed nature of peripheral

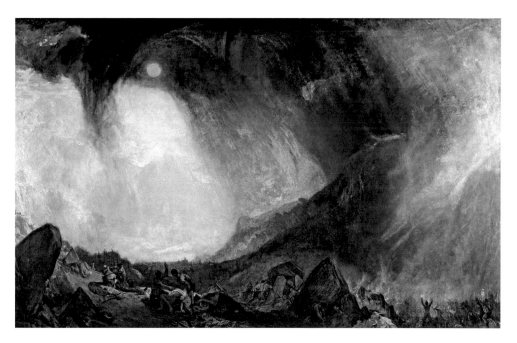

2.3 J. M. W. Turner, *Snow Storm: Hannibal and His Army Crossing the Alps*, exhibited 1812.

vision (Ghada Amer, Braun, James Perrin). Anomalous or extreme optical sensations suggest fields of pulsing energy (Anoka Faruqee, Wayne Gonzales). In the figurative or semifigurative works, the formal devices usually employed in abstract styles often jostle uncomfortably with bizarre imagery, generating seemingly incompatible, dreamlike, and nonrational hybridizing of the familiar into the exotic (Ahmed Alsoudani, Moon, Wangechi Mutu, Neo Rauch, Corinne Wasmuht).

Indeed, many of the works in this exhibition strive for the kinds of affects that, since the 18th century, have been defined as "sublime." Turner's work, for example (see figure 2.3), is a paradigm of "open" painting, and was informed by the artist's interest in the concept of the sublime, which in essence deals with the complex role played in consciousness by sensory and cognitive deprivation and overload. As Edmund Burke wrote in the influential *Philosophical Enquiry into the Origins of Our Ideas of the Sublime and Beautiful* (1757):

Anything which elevates the mind is sublime, and elevation of mind is produced by the contemplation of greatness of any kind. . . . Sublimity is, therefore, only another word for the effect of greatness upon the feelings—greatness, whether of matter, space, power, virtue, or beauty: and there is perhaps no desirable quality of a work of art, which, in its perfection, is not, in some way or degree, sublime.[5]

But, as Burke went on to emphasize, such "elevation of mind" also necessarily involves anxiety, fear, and pain, because we are pushed to the limits of what is knowable and controllable. Thus, as Robert Doran writes in a recent study, the sublime encompasses a complex melding of opposites:

The tension between these two poles of a single experience—of being at once below and above, inferior and superior, humbled and exalted—produces the special dynamism of the sublime, creating nexuses with diverse areas of human reality (the religious, the political, the social, the anthropological).[6]

The focus of the concept of the sublime was originally the emotional response to the infinite magnitude of nature, but today it is just as likely to be discussed in relation to the overwhelming experience of the human-made technological world, where it is often invoked to characterize a wide variety of contemporary artworks.[7] Ultimately, the experience of the sublime entails traveling outside the normal and safely demarcated world we customarily inhabit, while staying within a marked-off or "formatted" space that allows us to have a taste of an exalted yet also potentially dangerous experience without actually risking our lives. It explores what can happen when we escape from the enclosure we call "ordinary life" but do not wander too far into the "radiant abyss."

Yet when it comes to evoking such extremes, what can be achieved today through painting looks very circumscribed compared to what is possible in other more immersive and interactive media. Artists who are in pursuit of the "sublime" experience are more likely to use media that can bring about higher levels of sensory confusion or shock than paintings can ever achieve. Compared to real life, but also compared to other artistic media, the ability of painting to directly engender intense feelings of physical vulnerability, heightened emotions, and expanded imagination seems very limited.

But it is precisely because of the explicitness of painting's frame and its concrete materiality that it can play a special role in facilitating a dialectical awareness of an expanded, or de-centered, perception, and, as a result, also of an expanded consciousness. Recent models use metaphors of the "continuum" or the "spectrum" to suggest that consciousness is best understood as a collection of complex emotional and cognitive events that blend and merge within mind and body.[8] As David Lewis-Williams describes it, at one end of this continuum are outer-directed, waking, problem-oriented thoughts (the kind you are using to read this essay). Then, as we move progressively inward, there are states with less relevance to external reality, such as realistic and "autistic" (inner-directed, and with minimal affective interaction with the world) fantasy. Further inward, we slip into reverie, hypnagogic—falling asleep—states (often enough, the end result of reading this kind of essay!), and finally, the completely inward condition of the dream state.[9] During the course of a normal

day, we are likely to experience all of these states, but we identify our conscious selves—our egos—almost completely with the type of consciousness associated with the outer-directed end of the spectrum. This is for a simple evolutionary reason: it has greater adaptive advantages. At birth, the brain is a reservoir of immense potential, but it is immediately flooded with the experience of the world, and the openness of perception is closed down to increase the possibilities of survival. Experience is structured so that we can make a sharp distinction between ourselves and the world, and this, in its turn, provides us with a sense of ontological autonomy and existential security.

The basis of this ability to "frame" the world lies in the neurophysiology of vision—in the ability of our eye to draw the surrounding environment around a focal point and to flatten space, thereby delivering clear and distinct detail. We then use this visual capacity to organize and stabilize the cognitive field as what psychologists call a *Gestalt* or structured whole, so that this also presents itself to consciousness as clear and distinct. In other words, we are biologically predisposed to structure the world by organizing our perceptions and thoughts into stable and familiar patterns. So, the idea of the "frame"—of segregating something off for special and sustained attention—is deeply embedded in consciousness.

The literal frame of a painting is thus also like the metaphorical frame we impose on lived experience. But as the paintings in the exhibition remind us, another purpose of art can be to communicate heightened awareness of the unbalanced configuration of space before the construction of a stable "reality." Indeed, they can remind us that what we think is "real" is actually a cognitive construction—an "ego tunnel," as the neurophilosopher Thomas Metzinger calls it. He writes, "Our conscious model of reality is a low-dimensional projection of the inconceivably richer physical reality surrounding and sustaining us."[10] For example, our cognitive habits conceal the fact that we are not seeing everything at once—contrary to what we believe—but rather in glimpses, and that what we see in sharp focus is really only a very small part of the total visual field. For the greater part of our waking life, we hone our attention into a tiny luminous zone within the total enveloping environment through which we move our bodies.

But making small shifts away from this "normal" "tunnel" consciousness is as easy as temporarily immobilizing or diminishing the dominance of focused vision—for example, as we do during twilight, or in more extreme and abnormal situations of sensory disordering, such as when we drink too much or take psychotropic drugs. At such times, the power of alert consciousness is blunted, and a more elusive kind of world emerges. The normal activity of dreaming gives us all some idea of what altered states of consciousness are like.

The paintings in *Chaos and Awe*, with their dispersed and radically confusing compositions often militating against the dominance of the clear and distinct world of the focused vision of the "ego tunnel," remind us that the difference between what we classify as "real" and "hallucinatory" is really only a matter of degree rather than of kind. For, to describe one part of the full continuum of consciousness as "normal," "genuine," and "good," while others are deemed "altered" and "perverted," actually exposes the fundamental cognitive prejudice we carry within us. Indeed, in some ways, we can say that the periphery of the visual field is more "truthful" than the focal center. As the philosopher Jean-François Lyotard writes:

This gap [between the center and the periphery of vision] gives much more than the here and the elsewhere, the front and the back. It gives the qualitative discontinuity of the two spaces in their simultaneity: the curved, twilight, fleeting, lateral space of the first peripheral contact with something, and the stabilized, constant, central rectangular space of the grasp in the foveal zone. This grasp is a seizing, a prehension, an impounding akin to a preying, laborious linguistic grip.[11]

In fact, from within the cramped enclosure of our "ego tunnel," the chaotic energies that swirl all around hold a special fascination. We sense that within them may lie exciting and dynamic elements of freedom, spontaneity, and vitality. The very limitations imposed on us by our social contexts and obligations make the desire to escape from their bonds all the more intense and alluring. Instinctively, we seem to know that by calling on such anarchic forces it will be possible to free ourselves, leave the enclosure, and change our worlds. For these so-called altered states of consciousness, when a less structured zone of the continuum of consciousness is entered, are characterized, above all, by what the "ego tunnel" deprives us of—a heightened awareness of existential and universal connectedness between self, others, and the world.

This experience has been called the "oceanic" feeling, and is evoked in *Chaos and Awe* especially, perhaps, in the paintings of Ritchie and Faruqee (figure 2.4) or Amer and Gonzales. But all the paintings in the exhibition lure us into what can be called a liminal state (the word comes from the Latin *limen*, meaning "threshold, surround, or lintel of a doorway," and also from *limes*, a boundary or limit). Such threshold situations span everything from the inner-directed hypnagogic states we inhabit between sleeping and waking to more extreme situations, such as when we lie at the margin between life and death. At these times, "the envelope, which separates and divides us, fades away," as the philosopher Luce Irigaray writes. "Instead of a solid enclosure, it becomes fluid: which is far from nothing. This does not mean that we are merged. But our relationship to place, which maintained our hierarchical difference, takes on different properties."[12]

2.4 Anoka Faruqee, *2013P-85*, 2013.

Socially, the liminal state signals the presence of a borderline or a margin that is potentially dangerous to the status quo, and it is therefore a source of anxiety, to be policed by taboos. Religions have traditionally served as the liminal's social channel, and here, the destabilizing energies that are always periodically released are absorbed into socially accepted forms, and channeled into rituals. Historical, anthropological, and sociological studies show that within human societies a tension has always existed between the rigid structures we are obliged to adopt as members of a community (which is the "frame" around the central focal point that we often consider to be "consciousness") and the unstructured insights we gain into a deeper reality.[13] These tensions often arise during periods of flux and less inhibited social situations—an equivalent to peripheral vision, which takes us to the edge of the frame and beyond, stretching our minds toward infinity.

Liminal moments are a constant of human consciousness throughout time, and in aberrant situations they can even seem virtually permanent. In modern secular Western society, however, where the hold of traditional beliefs has loosened and traditional

rites of passage have lost their value, the ritual processes that once worked to link different parts of the continuum of consciousness have become severely eroded. Indeed, in this situation, which can arguably be seen within the sweep of history as an extended aberration, the arts have often sought to function as secular ritual processes, thereby hoping to channel the liminal toward socially beneficial ends.

What is especially evident in the works in this exhibition is how the geometrically formatted surfaces of painting function in one way or another to create an inside and an outside, while at the same time serving as an opening onto this outside. The contingency of a painting's frame—its "openness" in the sense meant by Wölfflin—then suggests it is a porous entity that, while addressing the necessity of containment (of "framing") at the same time points toward states of noncontainment that embrace a greater part of the continuum of consciousness. A painting then becomes less something structurally fixed in space, and more a temporal event. It functions as a place of encounter, because the frame is not placed in opposition to the openness that lies beyond it, but rather is the precondition for making us aware of such openness. The pictorial spaces thereby created are not airtight, immobile limits, but rather interactive and relational thresholds. For being "open" is not the same as being all-inclusive, and the truly chaotic and awesome in this sense are not "open," simply because they have no outside. The presence of the framing edge and the concreteness of the surface are exactly what permit a painting—however apparently chaotic or formless its composition—to function as something more than simply a provoker of sensations. A painting then becomes a *phase* within an ongoing "ritual process" whose ultimate goal is not the total rejection or deconstruction of "normal" consciousness—an impossible task in any case—but rather its de-centering through the juxtaposition of the finite horizon established by the frame and surface *and* the invisible, uncontainable, and unnoticed circulations occurring in the spaces beyond the frame. By bringing signs of liminality within a delimiting rectangle, a painting demonstrates and channels the dynamic tension that always exists between the destabilizing yet emancipating insights we get during periods of flux and within less-structured consciousness, and the hierarchical, status-bound structures we must accept as members of society.

Notes

1. Matthew Ritchie, "Postscript: Into the Radiant Abyss" (unpublished manuscript, June 14, 2016), PDF file.

2. John Dewey, *Art as Experience* (1934; repr., New York: Perigee Books, 2005), 49.

3. Gilles Deleuze, *Cinema 1: The Movement-Image*, translated by Hugh Tomlinson and Barbara Habberjam (Minneapolis: University of Minnesota, 1986), 14–15.

4. Heinrich Wölfflin, *Principles of Art History: The Problem of the Development of Style in Later Art* (1915), translated by M. D. Hottinger (New York: Dover, 1950), 124–48.

5. Edmund Burke, *A Philosophical Enquiry into the Origins of Our Ideas of the Sublime and Beautiful* (1757), edited by Adam Phillips (Oxford: Oxford University Press, 1990), 128.

6. Robert Doran, *The Theory of the Sublime from Longinus to Kant* (Cambridge: Cambridge University Press, 2015), 10–11.

7. For an overview, see Simon Morley, editor, *The Sublime*, Documents in Contemporary Art (London: Whitechapel Art Gallery; Cambridge, MA: MIT Press, 2010).

8. See, for example, Antonio Damasio, *Descartes' Error* (New York: Vintage Books, 1994); David Gelernter, *The Tides of Mind: Uncovering the Spectrum of Consciousness* (New York: W. W. Norton, 2016); David Lewis-Williams, *The Mind in the Cave: Consciousness and the Origins of Art* (London: Thames and Hudson, 2002); Thomas Metzinger, *The Ego Tunnel: The Science of the Mind and the Myth of the Self* (New York: Basic Books, 2009).

9. Lewis-Williams, *The Mind in the Cave*, 104–26.

10. Metzinger, *The Ego Tunnel*, 6.

11. Jean-François Lyotard, *Discourse, Figure*, translated by Antony Hudek and Mary Lydon (Minneapolis: University of Minnesota Press, 2010), 154.

12. Luce Irigaray, *Elemental Passions*, translated by Joanne Collie and Judith Still (London: Routledge, 1992), 59–60.

13. The seminal study of liminality in relation to social anthropology is Victor Turner, *The Ritual Process: Structure and Anti-Structure* (Ithaca: Cornell University Press, 1970).

3 A GATE, A KEY, AN OCEAN

MATTHEW RITCHIE

I'm that unnecessary but hopefully amusing mutation, a talking dog, a painter who writes, but I've never written much about painting. In this essay I'm going to reflect on how, over the last hundred-odd years, all our ideas of the known and unknown, the very framing through which we share the cosmic model that defines us, have been turned inside out—everted, even—unlocking new definitions of how we can imagine ourselves. I will also speculate on how a specific topological consideration of the oceanic possibilities of painting, one strongly gestured toward in this exhibition, might reflect aspects of this fundamental change.

Eversion is the name for the mathematical process whereby a sphere can be turned inside out without being torn, cut, or topologically changed. It seems to me that we are going through just such a comprehensive change. Over the last century, scientific discoveries have destabilized all notions of physical limits at every scale—astronomical, planetary,

biological, and atomic. The once-dominant perception of an ordered cosmos has been undone, the key of information unlocking the gate to

> a dark
> Illimitable ocean, without bound,
> Without dimensions; where length, breadth, and highth,
> And time, and place, are lost;

presided over by the throne of Chaos.[1] In outer and inner space, both once perceived as inconceivably distant from us, we have found information, broadcast on every frequency. In every cell, a government; in every body, a garden; in every atom, a revolution; behind every door, an ocean. Nietzsche's universal darkness has become a radiant abyss, illuminating the "irreducible différence" between the ideas of play and history articulated in 1966 by Jacques Derrida in "Structure, Sign, and Play in the Discourse of the Human Sciences,"[2] that critical gateway text that bridges structuralism and poststructuralism, whose themes are once again highly relevant to a moment when "the structurality of structure"[3] can, must, be thought about again, a moment of eversion.

In itself, the sense of a vertiginous depth waiting just outside the frame of perception is nothing new. In his synthesis of the earliest myths, Hesiod concluded that the universe originated with Kaos, "a shapeless mass."[4] In his telling, this primordial absence emerged concurrently with Gaia, or what we would now call nature and Eros, or the principle of procreation. This trinity was quickly followed by, or caused, the appearance of Tartarus, a sort of shadow. All four concepts were understood to be complementary processes in an inherently structural relationship, as well as places and even personages—"daimons," in the Hellenistic sense of personified forces. The sources of these primordial entities were located before time and beyond space, allowing classical thinkers to agree that Chaos was, uniquely, both within the universe and outside it. Together, they provided a rough but effective frame for the initial conditions of the cosmos, an ontological limit qualitatively different from the universe that followed.[5]

What is striking is how consistent the four basic framing terms of the universe have remained since that time. This fourfold structure, which I will observe in the diagrams that follow, reflects that history, using changed names for similar relationships.

Hesiod, like many authors that followed him, sought to draw a distinction between this mythic chaotic "time before time" and the bucolic order of a vague "Golden Age," a more favored subject for artists over the next two millennia. Each time we have questioned whether the universe is larger than we supposed, from the concentric spheres of Aristotle to the few thousand visible stars seen by the first telescopes and the kingdoms of "animalcules" found by the first microscopes, to the distant

3.1 The Hellenistic terms that framed the cosmos.

galaxies, singularities, and fundamental particles we can observe today, we have also tried to arrest this expansion, declare a new boundary, and establish a frame, and from that, isolate an image, situated within an ordered theory of picture. Each image has attempted to corral the unequal elements of the universe into a group of commensurate relations that metaphorically embody, at their heart, the power relations embedded in the collections of art, objects, and humans that characterize their time.

Severed from their contexts and their crimes, those frozen images, bloodied and crowned, robed and naked, painted on cave walls, screens, scrolls, books, vases, wood, linen, and canvas supports, stroll serenely through the ages, proffering their scripted explanations of how the big picture used to fit together. By the 18th century, visual artists were picnicking within the prescribed aesthetic modes of the "sublime," the "natural" (or "real"), and the "ideal," terms that still constitute part of the framing of

this, and every, exhibition. Using a prototypical form of Instagram filter, 18th-century aesthetic tourists would carry Claude (Lorrain) glasses that "transformed the landscape into a provisional work of art, framed and suffused by a golden tone, like that of the master's paintings," as the moderns sought to build "a theoretical bridge between the ideal of the old pastoral, the imaginary landscape of reconciliation, and a new attitude towards the landscape more congenial to a scientific and commercial age."[6] Where the four modes convene and are occupied by human figures, they located the "picturesque." Notably, each pictorial mode implies a paired negative, easily invoked by a simple inversion summoning the correspondingly awe-ful, disfigured, ugly, and surreal, combining into the antithesis of the picturesque, the "grotesque." This evolution in conceptions of nature, from the primitive to the pastoral and then on to the intensely cultivated landscapes of today, led to an institutionalization of the relations between self and nature, still evident in the "portrait" and "landscape" formats we are authorized to use when we print a letter from a computer. For many artists, the growing presence of the "machine in the garden" could be translated to the "machine in the studio," as the vast forces of the sublime and the natural were gradually corralled by new technologies.

In the postwar period, modern artists, as nostalgic for their own Golden Age and as unnerved as everyone else by the recent discovery of an infinite space-time, embraced the metamorphic alterity of the grotesque, moving it from the periphery to the center. The strategies of interwar surreality, induced randomness, disfiguration, and distortion have proved enduring, the modes of the grotesque becoming core languages of 20th-century art and design. But however disruptive or necessary the escape from the picturesque might have seemed, the grotesque style become so easily adapted to popular culture, so commonplace in cartoons, horror movies, and album covers, as to offer its own form of comfort.

The emergent, inhuman spaces of the radiant abyss and the transactional, corrosive, and exponential technologies that most faithfully represent it are far more difficult to include in any such easy neurological or semantic relationship. As information deduced from the basic structure of the universe becomes the latest operating code of humanity, politically and pragmatically framing how we understand and operate in an increasingly shared world—or, indeed, in an art exhibition—the factorial categories of image, information, and material are becoming irrelevant. Just as the abstruse mathematics of chaos theory now underlie our understanding of the natural order, the "seminal adventure of the trace"[7] is becoming an algebraically determined predictive profile, both aggregated and distributed in form. Informational collisions remain the surface currency of culture, but carefully distinguishing between the frame, web, or network and its symbiotic content or code becomes difficult when you can buy an imaginary currency and use it to buy real drugs, when half the Internet "traffic" is

3.2 The complementary framing terms of the "picturesque" and the "grotesque."

generated by robots, when you can watch a real-time simulation of all the births and deaths in the world, when you can track down imaginary animals and take your picture with them, or when you can listen to the collisions of black holes while watching the feed of a drone flying over the ruined cities of Syria.

Whether or not we care, or see all this as bootstrapping us toward the next Golden Age or as a harbinger of the end of days, it's happening—the tidal flood of the radiant abyss is infiltrating our social spaces, government, medicine, and communication. Along with the exotic experiments of high-temperature physics, quantum information technologies, biomedical manipulations, and our dependence on petrochemicals to sustain us have all redefined the relationship of humans to nature. Such massive increases in distance increase yet attenuate the scale of any individual gesture, decreasing access to the shared space of culture and limiting our ability to

play. As this hierarchy problem grows, the void in the cultural space, the blank spot in the picture, grows along with it. The metaphysical danger of this shadowy space is that it becomes an autonomous but invisible "Claudian" filter for the chaos of reality. A new Tartarus—where the unloving minds of emergent AI, engineered to be the consummate bricoleurs of our most trivial desires, tint the world in the golden tones we prefer to experience. This is precisely where painting, the stubborn residue of individual human presences, the survival of the Orphic trace of the living in the cities of the dead, is becoming more significant—not less—to any meaningful reading of informational space.

As I have returned to the question of the human trace in the ocean of meanings, it might be useful to refine the distinction between painting, picturing, and image-making discussed earlier. *Painting*, like *building* and *meeting*, is a mysterious oddity called a *deverbal noun*. "I see the painting" could mean "I see someone painting" or "I see a completed painting." When I've finished painting, I've made a painting. But I can also still be painting while I am looking at the painting I'm painting. *Painting* is an index, or language of objects also called *paintings*, that is also an utterance, a performance, or a process of painting by a painter, whose presence and trace are as intrinsic to the act of painting as to the finished painting. The way painters decide when paintings are finished and become "painted" is both a narrative and a formal procedure, directly related to how we think about when reality is finished and "picturable"—a similarly ongoing process.

There is no beginning or end to this kind of looping, and the two forms of *painting*, verb and noun, form a Saussurean dyad of index and gesture, *langue* and *parole*, that has long stimulated intense critical interest. Aristotle called this state of affairs *entelechy*, where potential is defined by its process rather than its end—a procedural state of being wherein *entelechy* incorporates the concept of "telos," or ending, but the "end" is absolutely understood to be only where the next beginning commences. In some ways, the infinite loop of "painting" seems to be a way of getting around invidious philosophical assertions of any difference between "being" and "becoming," a work-around that is essential to understanding not only "painting" but "reality," which is also a place, or object, that is entirely in process, but entirely complete in its process. I like to think that the old "English" people (whose identity is equally fluid), when they decided to reserve this kind of subset of gerunds for a few very specific activities and objects, thought that paintings, like buildings and meetings, are processes and objects and subject to occupation and context, and that this idea was strangely important to them in some pretty deep ways—but they were notoriously imprecise, or might simply have been drunk.

Despite the distinctive and apparently narrow range of conditions under which painting functions, the enormous diversity of conditions and surfaces where painting

has manifested, almost covariant with human activity, strongly suggests that it is more flexible than it might appear. Beyond the grotesque, Gilles Deleuze identified three specific adjacent strands of postwar painting that oriented themselves toward then recently exposed infinities of time, space, and mass destruction without denying the ungrounded cosmography of post-Einsteinian space: optical abstraction emphasized theory and reduced visual chaos to a minimum (precursors to today's "zombie formalism"); abstract expressionism emphasized nature and extended visual chaotic potential to the local maximum; and a kind of hybrid form borrowed from the grotesque, the optical, and the expressive, with a central fold or cusp forming around the point at which the entire system collapses.[8] His preferred example of this form was Francis Bacon's paintings, which now seem both antiquated and prescient, diagramming the geometry of the existential abyss without ever quite falling in. The remnants or ghosts of all these strategies, the traces of painters past, can be felt throughout this exhibition. One might say that whenever the question of an interpretable or codified visual space-time is reopened, the deverbal noun *painting* is activated.

But this is not the goal of painting; indeed, one of the foundational myths of art history we can most usefully dispense with is that painting has any kind of "goal" at all, or has ever worked hard to be first in some kind of imaginary technological race. Although technologies have been developed to stimulate and simulate its components, painting is unique, in that to truly componentize it is to stop it being, in the purest sense, painting at all. Even the omnipresent rise of digitality, which seems in some ways quite close to a componentized language, where instructions are coded into atomic matrices and embodied in digital media and nanotechnology, is supported by a space where the distinction between information and material collapses. The painting surface is a suspended-phase space, a trampoline, stretched tightly over the radiant abyss. Long after they are "painted," paintings remain in a psychochemical flux, as binders and pigments slowly bloom and fade. On this informational and material exchange surface, painting connects across and collapses boundaries, easily co-opting the categories of real and unreal, personhood and immanence. Angels and demons, metaphors and allegories, typefaces, drips, stains, and swipes share space with dancers, seamstresses, factories, fish, apples and cheeses, the living and the dead.

Whatever the technical specifics or relative flux of an individual historically located surface, painting as process, object, or theory is not static, not quite solid or liquid; it is connective, interstitial, and plasmatic. Manuel DeLanda's examinations of an exploratory and expressive atomic materiality are as inherent to the painter and the painted as to the surface and the medium.[9] Most essentially, "painting," in all the forms discussed here, means the painter has shown up and something has been painted. *Painting* comes to mean everything that can be painted—which is a term closer to

the way radar "paints" a target, where a hitherto invisible presence is "acquired" or narrated into a location in time and space—a definition that can be expanded to other forms of media, such as film and music, that we may not think of as "painting" but might happily call "painterly." Painting is thus uniquely able to fuse epistemic and technological change, creating a second historical horizon, and the moment it first incorporates something new into itself becomes a significant contribution to its own history. It is not that painting does not find a way to use new technologies—painting finds a way to use everything; it is that the relation is always a historical subset, or instar, of the endless entelechal process of painting. In this particular way, its entelechy is constantly regenerated.

Some readers may have noted that the poles shown in the diagrams not only follow a convention which goes all the way back to Hesiod but roughly correspond to the quadratic layout most recently employed by the contemporary American philosopher Graham Harman for his "Quadruple Object."[10] If the strength, and weakness, of Harman and the group sometimes known as speculative realists lies in a too-easy universalization of terms, including any useful definition of humanity, then painting, in the sense I am describing here, can trigger a phase shift, a rupture in that universalizing process. It seems plausible that this central condition both occupies and provides its own surface of exchange and is sufficiently distinct from the four poles to constitute a "Quintuple Object"—a fifth state of matter, with attributes all its own.[11]

We certainly need such a new exploratory surface, floated over the infinite ocean of possibility, to help redefine connection, exchange, and play. We are halfway through a human-originated mass extinction and we live in a universe of which only 5 percent is even perceptible to our most advanced machines. When our neurotypical consensus, our shared ability to form a picture, is insufficient or maladapted for a sensory model that has simply outpaced us, culture is without access. Individual and social action are compromised and the game is frozen, locked between outdated and antagonistic theories of picture. An increased sense of chaos and awe is certainly one correct, if partial, response. It is likely that the vast and unknowable portions of reality, toward which we feel awe, or fear, cannot be fully pictured under these conditions, but perhaps they can be "painted" under the more general definition of *painting* as both object and process that I have essayed here.

Painting excels at allusion, joking, implication, gesture, and impression, the implausible in pursuit of the unrepresentable, offering itself as a space in which difficult encounters can be conjured without consequence. Painting ruthlessly enjoys, in this sense, the decentered space and time of *freeplay*.[12] Chaotic systems are prone to topological mixing. Over time, any open region will eventually overlap with every other region, evolving rapidly to coerce, copulate, collaborate, and corrupt—all things that paintings do exceptionally well. The spaces of mathematics, play, painting and life can all be considered as taking place in versions of this kind of universalized

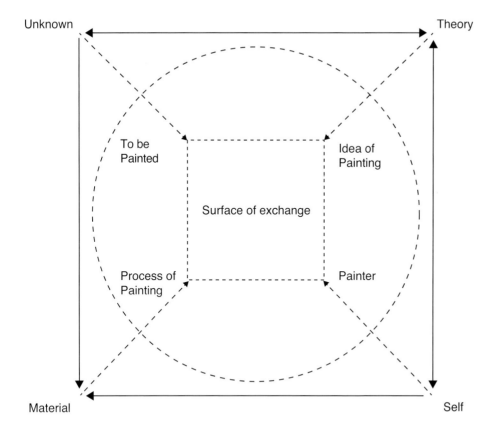

Unknown — **Theory**

To be
Painted

Idea of
Painting

Surface of exchange

Process of
Painting

Painter

Material — **Self**

3.3 The terms that frame the exchange surface of painting.

game-space. Indeed, in some ways, to be fully human is to play this "game of ends and means."

This is all a very different kind of play from the programmed and predictable confrontations and collisions of schematic informational space. Only by constantly reviewing, rewriting, and replaying the game can it be revised and transformed. The ghosts of previous painters and previously painted universes are only the winning strategies of the previous frame, the last round of the game. The rules cannot be ignored, for they are the laws of space and time, but they can be altered and transformed, crossing over the whole range of human engagements with the world. At each stage of the historical process, painting as idea, object, and process has not only adapted its ways and means of production but accommodated new assertions of who, and what, are the painter and the painted.

And while it is quite possible that painting still generates some medium-specific questions, just as any material or medium does, perhaps that is just not the most interesting question about painting anymore. Perhaps, more pertinently, we should ask, what does the fluidic exchange surface of painting still allow or provoke that other approaches cannot attempt as easily, or at all? Any representation of the radiant abyss must reflect our understanding that "it" (by which I mean "everything") is present, both within us and without. While the regimes of experimental physics, the information complex, the biomedical complex, and the petro-agrochemical complex mentioned earlier have all redefined the human framing of nature and picture, it is in their own natures to lurk outside the frame of representation. Despite this, they have each found a shadowy counterpart, eidolons for these hidden forces, in art forms such as informational abstraction, social practice, and body art, that can evoke what Donna Haraway has called the "pleasure in the confusion of boundaries" between machine and organism.[13] In figure 3.4, we can see how the increasing centrality of the radiant abyss to all human systems of exchange might stimulate the process of eversion. The radiant abyss illuminates us from within. Once cultivated by us, it is we who are now the experiment. The eversion pulls some contemporary concerns from the hidden edges back to the center, where they can be painted back into the picture.

Perhaps we can further speculate whether the fourth quadrant, the "unseen," might already be manifesting without our knowing it. We've already dispensed with the idea that any one thing is real or unreal, our reality being a fluctuating mixture of the two. How do we picture these new invisible presences, occupying what we previously understood as the very definition of absence? We might also ask whom, or what, we need to grant access to the operational spaces of culture as we adapt to this next planetary phase. The "illimitable ocean" is behind every door, the key sitting in our hands. Like the term used to define neurological and gender diversity, paintings exist on their own spectrum. In some of the ways I have described here, painting is a technology whose entire purpose is to depict the unknown becoming the known, from the human face to the arrival of steam trains, from the emergence of the object to its dematerialization, to essay forth, time and time and time again, to picture the space between demons and gods, nature and culture, ourselves and the world.

These terms call us to a metamorphosis. Each time the game-space, or exchange surface, of possible paintings grows, a new body is required in order to gain access to the larger space. To move, to play knowingly, is to be committed to a vision of self-transformation. If we turn away and squint our eyes, just a little, we can see that an everted figure, a new player, is emerging. So far, this figure has been unnameable—uncountable, even, as the terms by which we name and count cannot be easily applied. Like everything else today, they are also as much information as material. New spectra of cognitive traits, gender variance, and cross-cultural identity have already pointed to ways in which this figure might be manifested, and also to ways

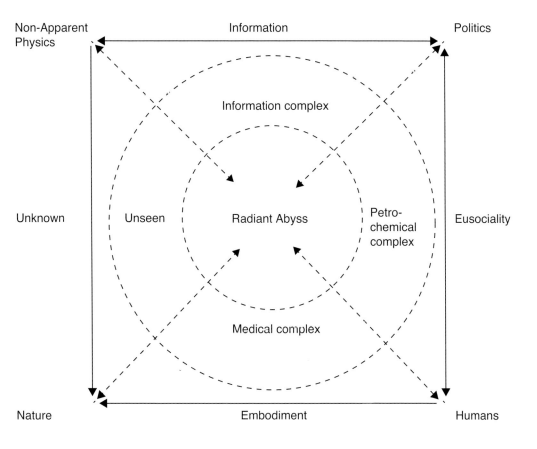

Non-Apparent Physics — Information — Politics

Unknown — Unseen — Radiant Abyss — Petro-chemical complex — Eusociality

Information complex

Medical complex

Nature — Embodiment — Humans

3.4 As the radiant abyss moves the center, it triggers an eversion, both allowing us to see the hidden forces around the edge of the frame and drawing (or painting) them in.

in which the human habit of cognitive disassociation re-presents itself at every scale. Eversion, like any complex process, is even harder to see than to think about. Freedom is not only the indeterminacy of play—the gambler's dream—but also committing to the indeterminacy of game construction, world building, picture making, the government of souls. Tens of millions of stateless humans have been consigned by *Homo economicus* to the limbo of partialized humanity that Giorgio Agamben has named *Homo sacer*[14]—migrants, outsiders, outlaws, rejects. But this is already too reductive: in every great migration there are coders, children, mothers, builders, hackers, rioters, free riders, future presidents, revolutionaries, and old-fashioned gamblers too. This is where we find Johan Huizinga's *Homo ludens*,[15] for whom play and risk are integral forms of sociocultural participation. Maybe we can even be

generous enough to find a slice of Carl Jung's "Collective Man."[16] You know what? We are all there.

Happily for this exhibition, painting—a process becoming an object whose occupation of space is both transitory and fixed—has historically taken an interest in connecting to, and embodying, each new space and scale as it becomes evident to the local neurotypicality. For, if this eversion is taking place, rippling through its many topological phases, every shade of the spectrum must, absolutely must, be included. And just as every possible person can exist, every painting can be made. Indeed, no single person or individual object can meaningfully express this new state in the way that we are used to. We'll need to propose an ethics of seeing, of painting, based on inclusion, not exclusion. We'll need our pictures to be more useful, whether we are in museums, on our phones, lost in artificial reality, or in some emergent combination of all three. We'll need them to be more than pictures, then—more than images, in all the ways they already are. For, although paintings are an instrumentalized form of nature, a neurological technology, an index of forms discovered over time—yes, yes, yes! to all of those things—they are also, finally, a presence. They oblige the painter (at least) to show up. And now, you have shown up too.

At the end of his 1966 essay, Derrida describes himself as guilty of turning away from "the face of the unnameable which is proclaiming itself." We do not have that luxury today. The face of the unnameable has turned toward us, is us. And so I name myself, as one of you and one of them, and you, whether friend, passerby, or enemy, as one of us, *Homo evertus*, part of the new multitude, and hereby promise perpetual revolution and swear eternal allegiance to the inside-out nation, which is to say, no nation at all, since time and space know no such boundaries. And as the world turns inside out and our shared body unfolds and unfolds, you'll know it's working, that we're getting there, when you feel larger. When you look at the new pictures and see equal parts "you" and "everything else." When you can see a part of yourself opening the gate, part of you drowning in the ocean, and all of you, by which I mean me, us, changing together.

Notes

1. John Milton, *Paradise Lost*, bk. 2, lines 891–94.

2. Jacques Derrida, "Structure, Sign, and Play in the Discourse of the Human Sciences" (1966), in *The Structuralist Controversy: The Languages of Criticism and the Sciences of Man*, edited by Richard Macksey and Eugenio Donato (Baltimore: Johns Hopkins University Press, 1972).

3. Ibid., 1.

4. Hesiod, *Theogony*, 116–20.

5. John Bussanich, "A Theoretical Interpretation of Hesiod's Chaos," *Classical Philology* 78, no. 3 (July 1983): 214.

6. Leo Marx, *The Machine in the Garden* (New York: Oxford University Press, 1964), 89, 93.

7. Derrida, "Structure, Sign, and Play in the Discourse of the Human Sciences," 12.

8. Gilles Deleuze, *Francis Bacon: The Logic of Sensation*, translated by Daniel W. Smith (New York: Continuum, 2003), 110.

9. Manuel DeLanda, "Deleuze, Diagrams, and the Genesis of Form," *ANY* 23 (June 1998): 30.

10. Graham Harman, *The Quadruple Object* (Arlesford: Zero Books, 2011), 79.

11. Neither precluding nor predicting the existence of sextuple, heptuple, or octuple objects that might correlate to newly proposed, discovered, or created states of matter, such as other bosonic and fermionic condensates.

12. Derrida, "Structure, Sign, and Play in the Discourse of the Human Sciences," 9. This is such specific definition that I think it may require a complete quote: "This field is in fact that of freeplay, that is to say, a field of infinite substitutions in the closure of a finite ensemble. This field permits these infinite substitutions only because it is finite, that is to say, because instead of being an inexhaustible field, as in the classical hypothesis, instead of being too large, there is something missing from it: a center which arrests and founds the freeplay of substitutions."

13. Donna Haraway, "A Cyborg Manifesto," in *The Cybercultures Reader*, edited by David Bell and Barbara M. Kennedy (London: Routledge, 2000), 292.

14. Giorgio Agamben, *Homo Sacer: Sovereign Power and Bare Life*, translated by Daniel Heller-Roazen (Stanford, CA: Stanford University Press, 1998), 47.

15. Johan Huizinga, *Homo Ludens: A Study of the Play-Element in Culture* (London: Routledge and Kegan Paul, 1949), 3.

16. Carl Jung, *Modern Man in Search of a Soul: Psychology and Literature*, translated by Carl F. Baynes with William Stanley Dell (London: Kegan Paul Trench Trubner and Co., 1933), 173.

PLATES

No Place

Technology has subsumed the idea of the sublime because it . . . is terrifying in the limitless unknowability of its potential, while being entirely a product of knowledge—i.e., it combines limitlessness with pure ratio—and is thus at once unbounded by the human, and, as knowledge, a trace of the human now out of the latter's control.

JEREMY GILBERT-ROLFE

The first section of the exhibition invites consideration of the "techno-logical sublime"—a feeling of unease, helplessness, and awe when contemplating the immeasurable impact of technology on the lives of individuals. Paintings in "No Place" suggest imagined maps of systems of communications, surveillance, and finance that influence personal behavior and political and social outcomes around the globe. Tran-scending geography and nationality, this interwoven set of networks is envisioned as being resistant to transparency, with inscrutable forms and bright, blank surfaces veiling the phantom exercise of control.

Plate 1 Peter Halley, *Amorphous Compression*, 2010.

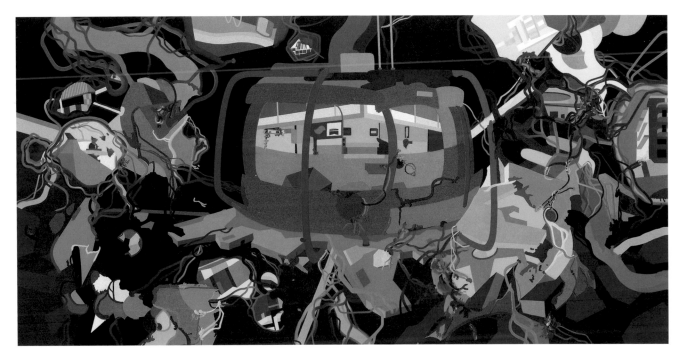

Plate 2 Franz Ackermann, *Untitled (yet)*, 2008–9.

Plate 3 Sue Williams, *Ministry of Hate*, 2013.

Shadows

In the same way that to become a social human being one modifies and suppresses and, ultimately, without great courage, lies to oneself about all one's interior, uncharted chaos, so have we, as a nation, modified or suppressed and lied about all the darker forces in our history.

JAMES BALDWIN

Paintings in this section address ideologies—imperialist, colonialist, capitalist, and even scientific—that have employed racial divisiveness in pursuit of political dominance, money, and other instruments and ends of power. A living history, racism is today hidden in plain sight. It is atmospheric and internal, a shape-shifter that spawns anxiety, fear, and social instability.

Plate 4 Neo Rauch, *Warten auf die Barbaren* [*Waiting for the Barbarians*], 2007.

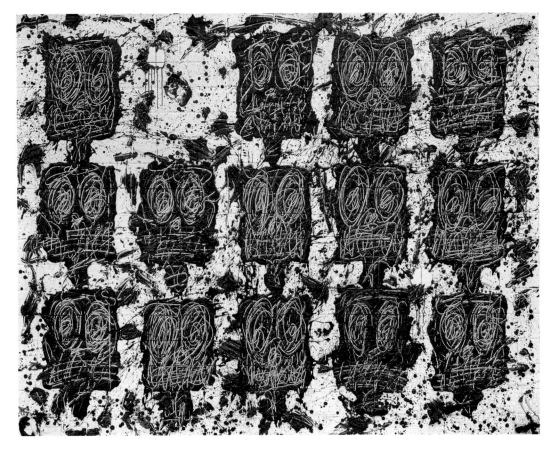

Plate 5 Rashid Johnson, *Untitled Anxious Audience*, 2016.

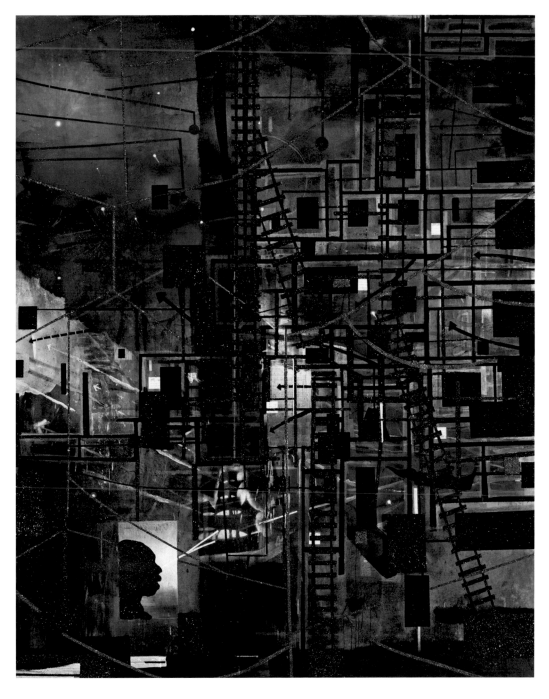

Plate 6 Radcliffe Bailey, *EW, SN*, 2011.

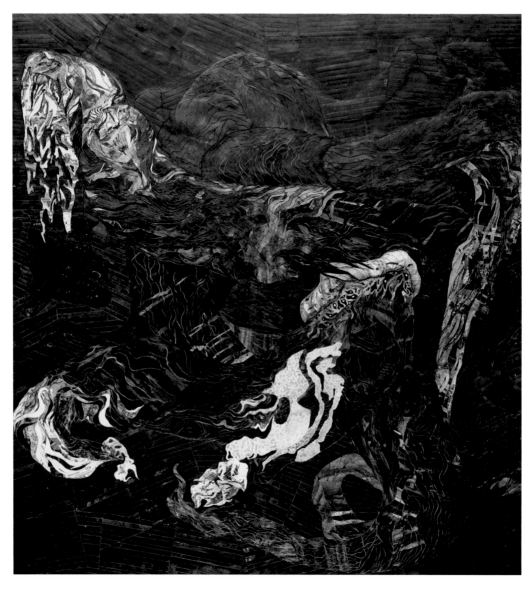

Plate 7 Ellen Gallagher, *An Experiment of Unusual Opportunity*, 2008.

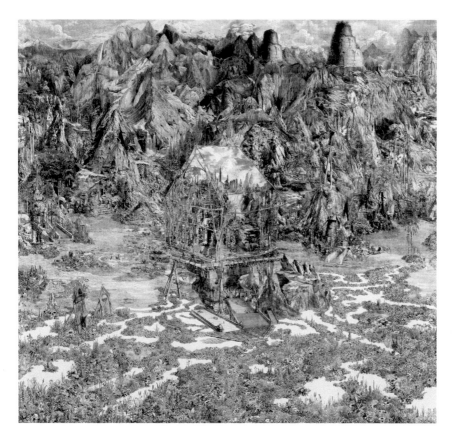

Plate 8 Dean Byington, *The Inquisitors*, 2011.

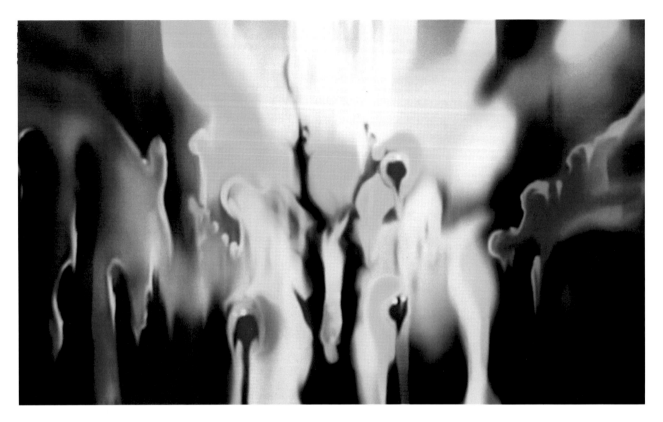

Plate 9 Jeremy Blake, *Winchester*, 2002.

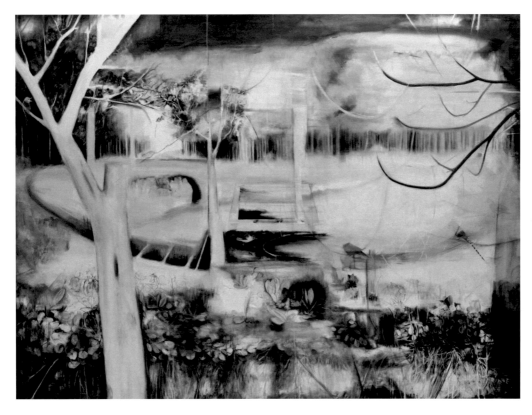

Plate 10 Nogah Engler, *Circling*, 2014.

Collisions

The bombings, the air raids; I witnessed so many ruins and chaos everywhere. When the vibrations and explosions of the air raids occurred my mother recalls I would make drawings to try to make sense out of what was happening. And I think that stays with me even now, where I still see the world as this chaotic, potentially dangerous place.

ALI BANISADR

Works in "Collisions" contain intimate responses to crises—war and terror, displaced populations, and clashing ideologies—that are virulent, elastic, and enduring. This section includes paintings by artists of Middle Eastern origin who convey the violence that has long plagued their region through images of fragmentation that go deeply into their own memories and the experiences of their communities. Instead of depicting particular instances of conflict, their seething masses and abstract layering internalize dissolution and dread, portraying the effects of war as a wrenching delirium.

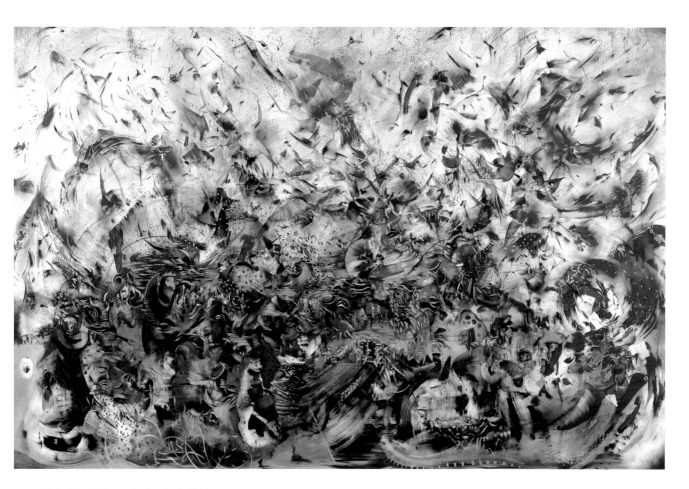

Plate 11 Ali Banisadr, *Contact*, 2013.

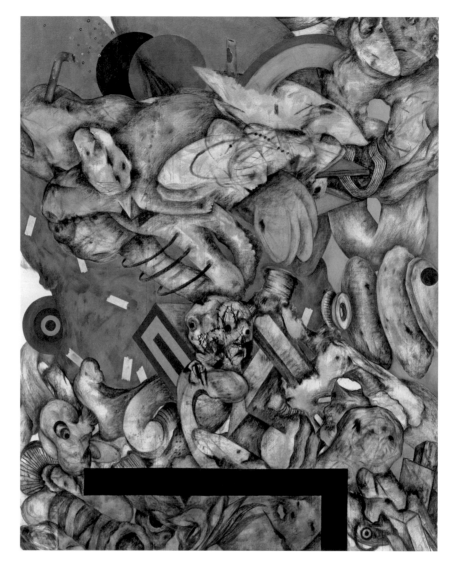

Plate 12 Ahmed Alsoudani, *X-Ray*, 2016.

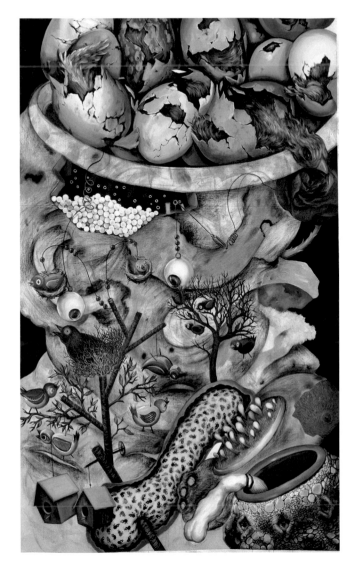

Plate 13 Ahmed Alsoudani, *Birds*, 2015.

Plate 14 Rokni Haerizadeh, *But a Storm Is Blowing from Paradise*, 2014.

Interzone

For contemporary creators are already laying the foundations for a radicant art—*radicant* being a term designating an organism that grows its roots and adds new ones as it advances. To be radicant means setting one's roots in motion, staging them in heterogenous contexts and formats, denying them the power to completely define one's identity, translating ideas, transcoding images, transplanting behaviors, exchanging rather than imposing.

NICOLAS BOURRIAUD

A profuse and polyglot imagery grows from encounters between disparate cultures. This section includes works that show dynamic mergers of polarities—colonized and colonizer, east and west, living and dead, past and present—as springboards of possibility, leading to the unexpected, from heightened conflict to fertility and new growth. Within this range, cultural hybridity generates a recalibration of perspectives that is, for better or worse, inherently transformative.

Plate 15 Wangechi Mutu, *Untitled* (from *Tumors*), 2004.

Plate 16 Wangechi Mutu, *Funkalicious fruit field*, 2007.

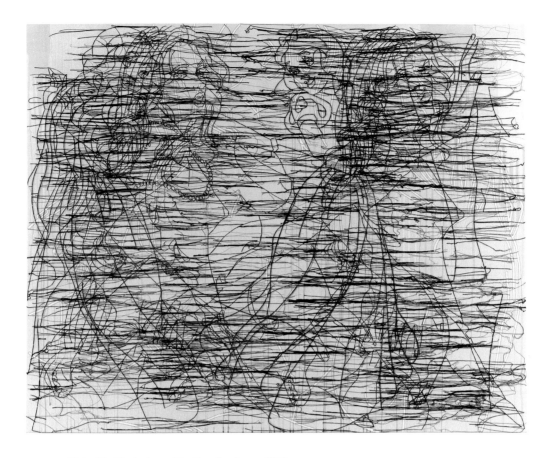

Plate 17 Ghada Amer, *The Egyptian Lover*, 2008.

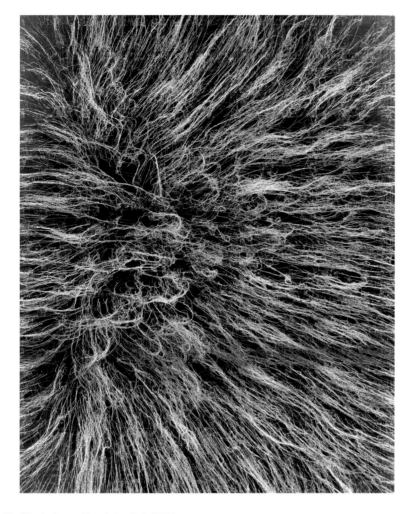

Plate 18 Ghada Amer, *Revolution 2.0*, 2011.

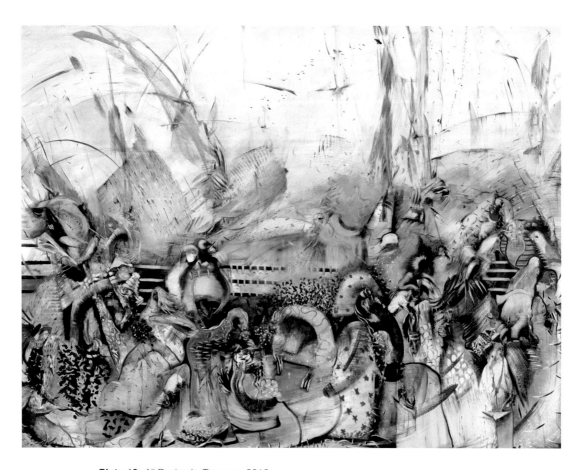

Plate 19 Ali Banisadr, *Treasure*, 2016.

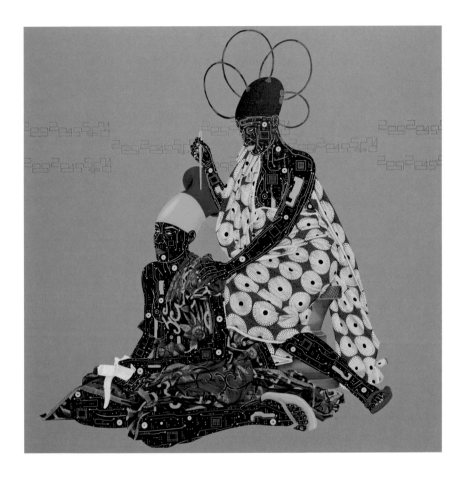

Plate 20 Eddy Kamuanga Ilunga, *Tambour II*, 2015.

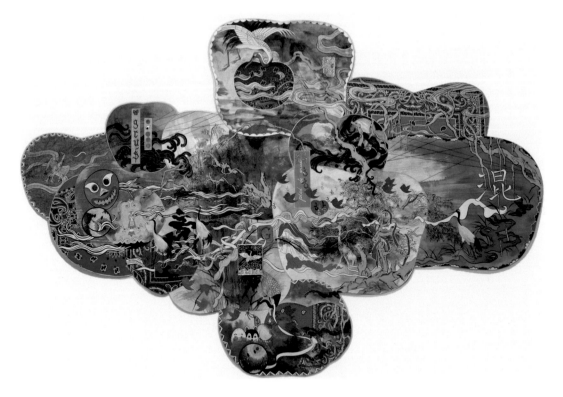

Plate 21 Jiha Moon, *Pied de grue*, 2012.

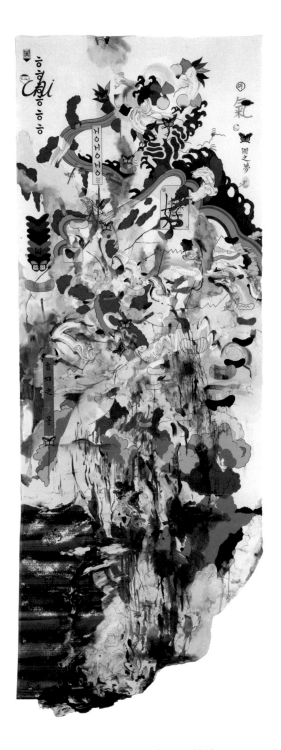

Plate 22 Jiha Moon, *Springfield—Butterfly Dream*, 2010.

Virtuality

But how are we to understand artists turning to the virtual worlds of *paintings* in the new millennium—their stubborn desire for this flat and static medium that is somehow imbued with the icons and energies of electronic life?

CAROLINE A. JONES

Paintings in this section have a spectral glow that signals their existence in the nether region between the physical and cyber worlds. However manipulable digital forms may be, their global availability and promise of limitless information has fed the notion that the virtual has overtaken the physical as a means of grasping the complexity of the social world, even as maladaptations—the dark web, evolving viruses, increasingly sophisticated uses of disinformation—make cyberspace ever more confounding. As the borders between truth and fiction are increasingly slippery, we realize that paintings have always provided fields of open possibility, conflating unreality with perception and holding the capacity to sustain the most blatant self-contradiction.

Plate 23 Wade Guyton, *Untitled*, 2005.

Plate 24 Wayne Gonzales, *Untitled*, 2009.

Plate 25 Wayne Gonzales, *Waiting Crowd*, 2008.

Plate 26 Wayne Gonzales, *Untitled*, 2007.

Plate 27 Corinne Wasmuht, *Bibliotheque/CDG-BSL*, 2011.

Plate 28 Rachel Rossin, *I Came And Went As A Ghost Hand (Cycle II)*, 2015.

Plate 29 Korakrit Arunanondchai, *Untitled (Body Painting 9)*, 2013.

The Boundless

At issue is not only the attempt to represent excess, which by definition breaks totality and cannot be bound, but the desire for excess itself; not just the description of, but the wish for, sublimity.

BARBARA CLAIRE FREEMAN

An exhilarating obscurity is conveyed in swirls, fields, and spatters of paint, used not to depict tangible reality so much as to define ephemeral conditions—liquid, gas, flame, and light—which function as corollaries of the restless mind's yearning to be unsettled. Rendering amorphous sensations, these open compositions imply an infinite expansion beyond the paintings' edge, underscoring the limits of our ability to perceive what lies outside our perceptual frames of reference, showing rational thought to be only a narrow subset of the mind's activities.

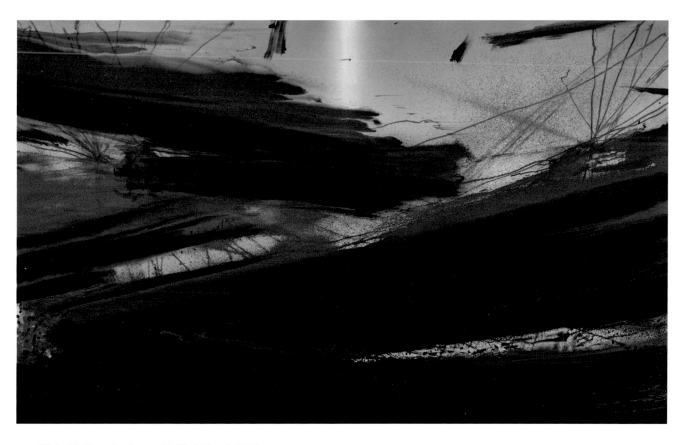

Plate 30 Barnaby Furnas, *Untitled (Flood)*, 2007.

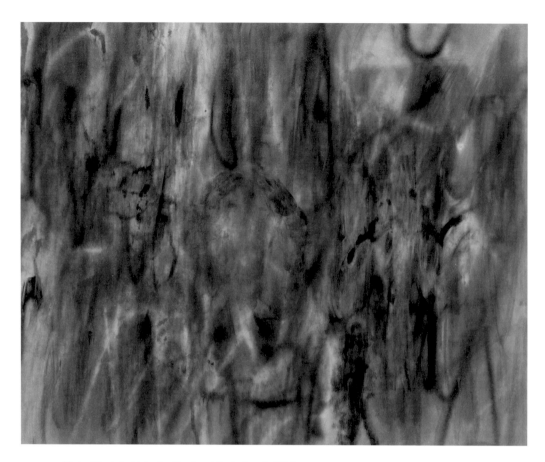

Plate 31 Julie Mehretu, *Conjured Parts (core)*, 2016.

Plate 32 Pat Steir, *White Moon Mist*, 2006.

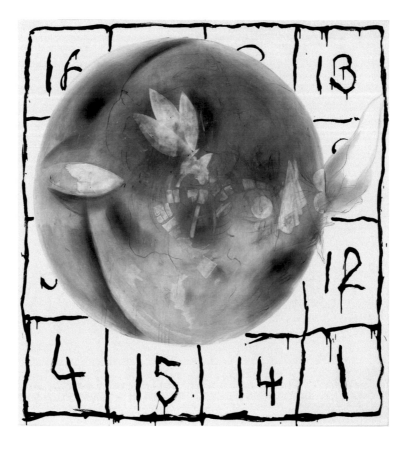

Plate 33 Charline von Heyl, *Melencolia*, 2008.

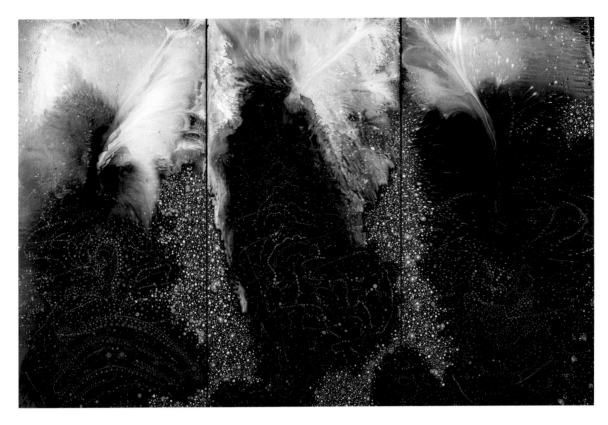

Plate 34 Barbara Takenaga, *Black Triptych (blaze)*, 2016.

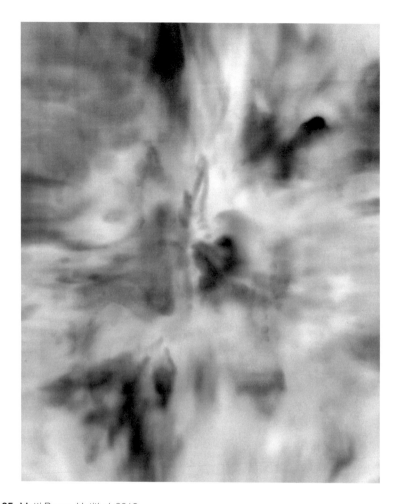

Plate 35 Matti Braun, *Untitled*, 2012.

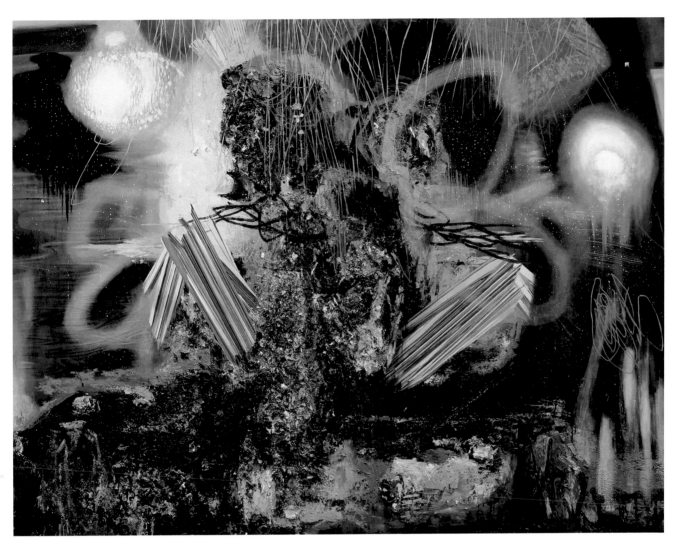

Plate 36 James Perrin, *Semiosis on the Sea*, 2015.

Plate 37 Heather Gwen Martin, *Trigonometric Functions*, 2010.

Everything

Did the desire for knowledge lead to this new type of image? Or did the desire for the image lead to this new type of knowledge?

ANOKA FARUQEE

Speculative charts of invisible energy and matter, technological systems, scientific measurements, mathematical theorems, and even philosophical premises, paintings in this section provide glimpses of a universe that is too complex for human understanding but nevertheless may reveal itself in tantalizing parts to be somehow connected. Hovering between order and chaos, these imaginary maps replace habitual perception and compartmentalized knowledge with inquiries into the expansive nature of being.

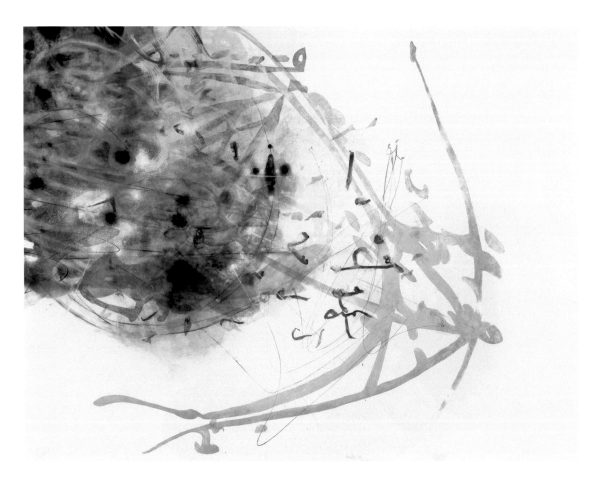

Plate 38 Matthew Ritchie, *A bridge, a gate, an ocean*, 2014.

Plate 39 Matthew Ritchie, *Monstrance*, 2014.

Plate 40 Dannielle Tegeder, *Lightness as it Behaves in Turbulence*, 2016.

Plate 41 Dannielle Tegeder, *Nocturnal System Drawing and Atomic Nightlight*, 2009–11.

Plate 42 Hamlett Dobbins, *Untitled (For M.R.M./J.N./D.G.G.)*, 2016.

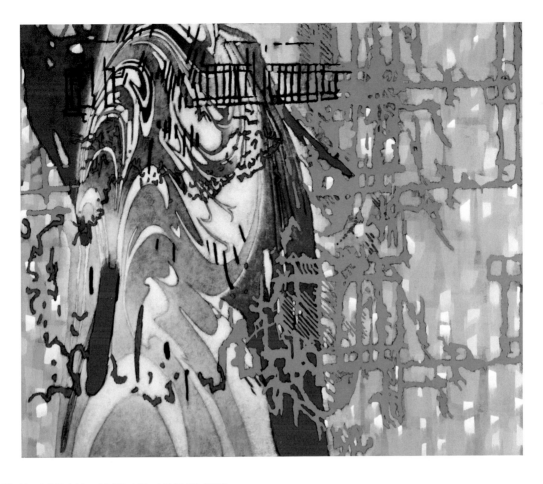

Plate 43 Hamlett Dobbins, *Untitled (For I.V./C.B.)*, 2016.

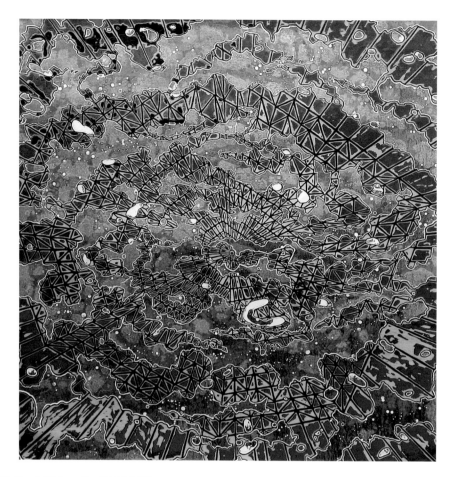

Plate 44 Sarah Walker, *Dust Tail II*, 2008.

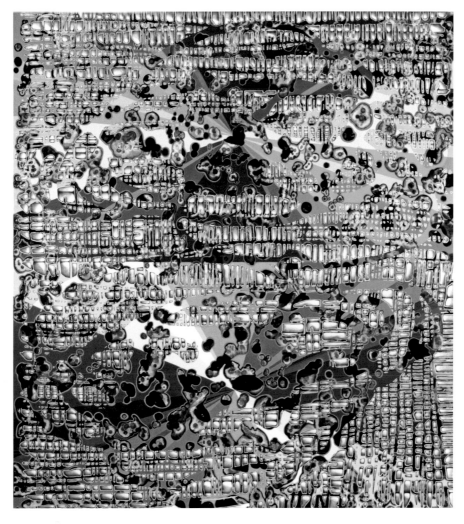

Plate 45 Sarah Walker, *Tanglement*, 2016.

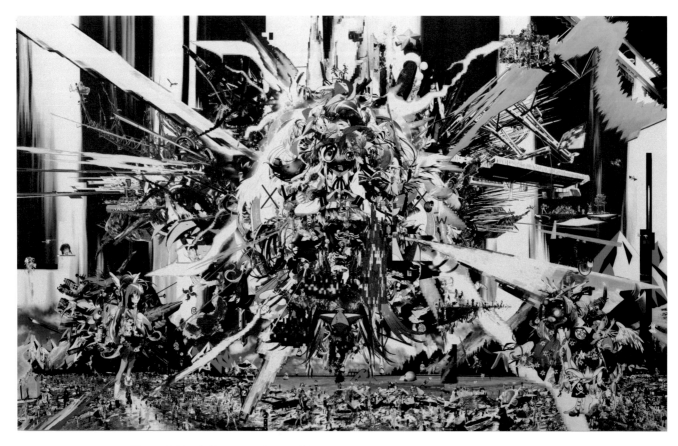

Plate 46 Kazuki Umezawa, *Over the Sky of the Beyond*, 2014.

Plate 47 Guillermo Kuitca, *Everything*, 2004.

Plate 48 Anoka Faruqee, *2013P-83 (Wave)*, 2013.

Plate 49 Anoka Faruqee, *2013P-85*, 2013.

Plate 50 Anoka Faruqee, *2013P-68*, 2013.

Plate 51 Pedro Barbeito, *LHC Blue* from *The God Particle*, 2014.

Plate 52 Pedro Barbeito, *LHC Red* from *The God Particle*, 2014.

Notes

Epigraphs: Jeremy Gilbert-Rolfe, *Beauty and the Contemporary Sublime* (New York: Allsworth Press, 1999), 127–28. James Baldwin, "The Creative Process," in *Collected Essays* (New York: Library of America, 1998), 672. Ali Banisadr in conversation with Boris Groys, in *Ali Banisadr: One Hundred and Twenty-Five Paintings* (London: Blain|Southern, 2015), 25. Nicolas Bourriaud, *The Radicant* (New York: Lukas and Sternberg, 2009), 22. Caroline A. Jones, "Fields of Intuition (in Four Proportions and Five Mods)," in *Remote Viewing: Invented Worlds in Recent Painting and Drawing*, edited by Elisabeth Sussman (New York: Whitney Museum of American Art, 2005), 81. Barbara Claire Freeman, *The Feminine Sublime: Gender and Excess in Women's Fiction* (Berkeley: University of California Press, 1995), 16. Anoka Faruqee, artist's statement, http://anokafaruqee.com/wp-content/uploads/the_visible_spectrum.pdf, accessed July 12, 2017.

ARTISTS IN THE EXHIBITION

Franz Ackermann

Ahmed Alsoudani

Ghada Amer

Korakrit Arunanondchai

Radcliffe Bailey

Ali Banisadr

Pedro Barbeito

Jeremy Blake

Matti Braun

Dean Byington

Hamlett Dobbins

Nogah Engler

Anoka Faruqee

Barnaby Furnas

Ellen Gallagher

Wayne Gonzales

Wade Guyton

Rokni Haerizadeh

Peter Halley

Eddy Kamuanga Ilunga

Rashid Johnson

Guillermo Kuitca

Heather Gwen Martin

Julie Mehretu

Jiha Moon

Wangechi Mutu

James Perrin

Neo Rauch

Matthew Ritchie

Rachel Rossin

Pat Steir

Barbara Takenaga

Dannielle Tegeder

Kazuki Umezawa

Charline von Heyl

Sarah Walker

Corinne Wasmuht

Sue Williams

LENDERS TO THE EXHIBITION

Albright-Knox Art Gallery, Buffalo, New York

Pedro Barbeito

The Broad Art Foundation

Carrie Secrist Gallery, Chicago

C L E A R I N G New York/Brussels

Curator's Office, Bethesda

David Lusk Gallery

DC Moore Gallery, New York

Larry Gagosian

Caren Golden, New York

Wayne Gonzales

Hall Collection, courtesy Hall Art Foundation

Hallmark Art Collection, Kansas City, Missouri

High Museum of Art, Atlanta

Koenig & Clinton

Indianapolis Museum of Art at Newfields

Miyoung Lee and Neil Simpkins, New York

Teresa and Bryan Lipinski, Nashville

Marlborough Contemporary

Mildred Lane Kemper Art Museum, Washington
 University in St. Louis

Mott-Warsh Collection, Flint, Michigan

Nerman Museum of Contemporary Art

James Perrin

PIEROGI

Pizzuti Collection

Private collection, Phoenix

RYAN LEE Gallery, New York

Joshua Rechnitz

Matthew Ritchie

Jordan D. Schnitzer

Solomon R. Guggenheim Museum

303 Gallery

Victoria Miro, London

Candace Worth

Glenn Scott Wright

ZieherSmith

ILLUSTRATION CREDITS

0.1 Rokni Haerizadeh (b. 1978, Tehran; based in Dubai), *But a Storm Is Blowing from Paradise* (detail), 2014. One of ten parts exhibited from a twenty-four-part work: gesso, watercolor, and ink on inkjet prints; each: 11 ¾ × 15 ¾ in. (30 × 39.9 cm). Solomon R. Guggenheim Museum, New York; Guggenheim UBS MAP Purchase Fund, 2015.89.9. © Rokni Haerizadeh

0.2 Rachel Rossin (b. 1987, West Palm Beach; based in New York), *I Came And Went As A Ghost Hand (Cycle II)* (detail), 2015. Virtual reality. Courtesy of the artist and ZieherSmith Gallery. © Rachel Rossin

0.3 Corinne Wasmuht (b. 1964, Dortmund, Germany; based in Berlin), *Bibliotheque/CDG-BSL* (detail), 2011. Triptych: oil on wood mounted on aluminum; each: 83 × 95 in. (210.8 × 241.3 cm); overall: 83 × 285 in. (210.8 × 723.9 cm). Collection Albright-Knox Art Gallery, Buffalo, New York; Sarah Norton Goodyear Fund, 2011, 2011:44a-c. © Corinne Wasmuht. Image courtesy of the artist and Petzel, New York

0.4 Jiha Moon (b. 1973, Daegu, South Korea; based in Atlanta), *Springfield—Butterfly Dream* (detail), 2010. Ink and acrylic, fabric, and embroidery patches on *hanji* (mulberry paper), 81 ½ × 30 in. (207 × 76.2 cm). Courtesy of the artist and Curator's Office. © Jiha Moon

0.5 James Perrin (b. 1975, Kenton, TN; based in Nashville), *Semiosis on the Sea* (detail), 2015. Oil on linen with acrylic resin, plant resin, paint scraps, and Tahitian pearls, 45 × 64 in. (114.3 × 162.6 cm). Courtesy of the artist. © James Perrin

0.6 Matthew Ritchie (b. 1964, London; based in New York), *A bridge, a gate, an ocean* (detail), 2014. Oil and ink on canvas, 94 × 120 × 2 ½ in. (238.8 × 304.8 × 6.4 cm). Courtesy of the artist. © Matthew Ritchie

1.1 Giuseppe Castiglione (b. 1829, Naples; d. 1908, Paris), *The Salon Carré at the Musée du Louvre*, 1861. Oil on canvas, 27 ⅛ × 40 ½ in. (68.9 × 102.9 cm). Collection of the Louvre, Paris. Photo: Erich Lessing/Art Resource, NY

1.2 Jacques-Louis David (b. 1748, Paris; d. 1825, Brussels), *The Oath of the Horatii*, ca. 1784. Oil on canvas, 129 ⅞ × 167 ⅜ in. (329.9 × 425.1 cm). Collection of the Louvre, Paris. Image © RMN-Grand Palais/Art Resource, NY. Photo: Gérard Blot/ Christian Jean

1.3 Ahmed Alsoudani (b. 1975, Baghdad; based in New York), *Birds*, 2015. Acrylic, charcoal, and colored pencil on canvas, 82 × 52 in. (208.3 × 132.1 cm). Courtesy of the artist and Marlborough Contemporary. © Ahmed Alsoudani

1.4 Adrian Ghenie (b. 1977, Baia Mare, Romania; based in Berlin, London, and Cluj, Romania), *Burning Books*, 2014. Oil on canvas, 74 ¾ × 51 ⅛ in. (190 × 130 cm). Collection of Mihai Nicodim. © Adrian Ghenie

1.5 Adrian Ghenie (b. 1977, Baia Mare, Romania; based in Berlin, London, and Cluj, Romania), *Untitled*, 2012. Courtesy of the artist and the Pace Gallery, New York. © Adrian Ghenie

1.6 J. M. W. Turner (b. 1775, London; d. 1851, London), *Slave Ship* (*Slavers Throwing Overboard the Dead and Dying, Typhoon Coming On*), 1840. Oil on canvas, 35 ¾ × 48 ¼ in. (90.8 × 122.6 cm). Museum of Fine Arts, Boston, Henry Lillie Pierce Fund. Photo: © Museum of Fine Arts, Boston

1.7 Ellen Gallagher (b. 1965, Providence, RI; based in New York and Rotterdam), *An Experiment of Unusual Opportunity*, 2008. Ink, graphite, oil, varnish, and cut paper on canvas, 79 ½ × 74 in. (201.9 × 188 cm). Collection of Larry Gagosian (promised gift to the Metropolitan Museum of Art). © Ellen Gallagher. Courtesy Gagosian

1.8 Ali Banisadr (b. 1976, Tehran; based in New York), *Contact* (detail), 2013. Oil on linen; support: 82 × 120 in. (208.3 × 304.8 cm). Collection Albright-Knox Art Gallery, Buffalo, New York; Gift of Mrs. Georgia M. G. Forman, by exchange, Bequest of Arthur B. Michael, by exchange, Elisabeth H. Gates Fund, by exchange, Charles W. Goodyear and Mrs. Georgia M. G. Forman Funds, by exchange, Philip J. Wickser Fund, by exchange, Gift of Mrs. Seymour H. Knox, Sr., by exchange, Gift of Miss Amelia E. White, by exchange, 2014, 2014:8. © Ali Banisadr. Photo: Tom Loonan

1.9 Rokni Haerizadeh (b. 1978, Tehran; based in Dubai), *My Heart Is Not Here, My Heart's in The Highlands, Chasing The Deers*, 2013. Gesso, ink, and watercolor drawings on printed paper, 11 $^{13}\!/_{16}$ × 15 $^{3}\!/_{4}$ in. (30 × 40 cm). Courtesy of the artist and Gallery Isabelle van den Eynde, Dubai. © Rokni Haerizadeh

2.1 Franz Ackermann (b. 1963, Neumarkt-Sankt Veit, Germany; based in Berlin), *Untitled (yet)*, 2008–9. Oil on canvas, 109 $^{5}\!/_{8}$ × 216 $^{1}\!/_{8}$ in. (278.4 × 549 cm). Mildred Lane Kemper Art Museum, Washington University in St. Louis, University purchase with funds from the David Woods Kemper Memorial Foundation, 2011, WU 2011.001. © Franz Ackermann

2.2 Ambrosius Bosschaert the Elder (b. 1573, Antwerp; d. 1621, The Hague), *A Still Life of Flowers in a Wan-Li Vase on a Ledge with Further Flowers, Shells and a Butterfly*, 1609–10. Oil on copper, 27 × 20 in. (68.6 × 50.8 cm). National Gallery, London, Great Britain, Accepted by HM Government in lieu of Inheritance Tax and allocated to the National Gallery, 2010. Photo © National Gallery, London/Art Resource, NY

2.3 J. M. W. Turner (b. 1775, London; d. 1851, London), *Snow Storm: Hannibal and His Army Crossing the Alps*, exhibited 1812. Oil on canvas, 57 $^{1}\!/_{2}$ × 93 $^{1}\!/_{2}$ in. (146.1 × 237.5 cm). Tate, London, accepted by the nation as part of the Turner bequest 1856. Photo © Tate, London/Art Resource, NY

2.4 Anoka Faruqee (b. 1972, Ann Arbor, MI; based in New Haven, CT), *2013P-85*, 2013. Acrylic on linen on panel, 45 × 45 in. (114.3 × 114.3 cm). Hallmark Art Collection, Kansas City, Missouri. © Anoka Faruqee. Photo: Jeffery Sturges, New York, courtesy the artist and Koenig & Clinton, New York

3.1–3.4 © Matthew Ritchie

Plate 1 Peter Halley (b. 1953, New York; based in New York), *Amorphous Compression*, 2009. Acrylic, fluorescent acrylic, and Roll-A-Tex on canvas, 80 × 80 in. (203.2 × 203.2 cm). Collection of Jordan D. Schnitzer. © Peter Halley

Plate 2 Franz Ackermann (b. 1963, Neumarkt-Sankt Veit, Germany; based in Berlin), *Untitled (yet)*, 2008–9. Oil on canvas, 109 ⅝ × 216 ⅛ in. (278.4 × 549 cm). Mildred Lane Kemper Art Museum, Washington University in St. Louis, University purchase with funds from the David Woods Kemper Memorial Foundation, 2011, WU 2011.0001. © Franz Ackermann

Plate 3 Sue Williams (b. 1954, Chicago; based in New York), *Ministry of Hate*, 2013. Oil and acrylic on canvas, 72 × 84 in. (182.9 × 213.4 cm). Courtesy 303 Gallery. © Sue Williams, courtesy 303 Gallery, New York

Plate 4 Neo Rauch (b. 1960, Leipzig, Germany; based in Leipzig), *Warten auf die Barbaren* [*Waiting for the Barbarians*], 2007. Oil on canvas, 59 × 157 ½ in. (149.9 × 400.1 cm). Collection of The Broad Art Foundation. © 2017 Courtesy galerie EIGEN + ART, Leipzig/Berlin / Artists Rights Society (ARS), New York

Plate 5 Rashid Johnson (b. 1977, Chicago; based in New York), *Untitled Anxious Audience*, 2016. White ceramic tile, black soap, and wax, 73 × 94 ½ × 2 ½ in. (185.4 × 240 × 6.4 cm). Private collection. © Rashid Johnson

Plate 6 Radcliffe Bailey (b. 1968, Bridgeton, NJ; based in Atlanta), *EW, SN*, 2011. Acrylic, glitter, and velvet on canvas, 144 × 96 × 8 in. (365.8 × 243.8 × 20.3 cm). High Museum of Art, Atlanta, purchase with funds from Alfred Austell Thornton in memory of Leila Austell Thornton and Albert Edward Thornton, Sr., and Sarah Miller Venable and William Hoyt Venable and the Radcliffe Bailey Guild. © Radcliffe Bailey, courtesy of the artist and Jack Shainman Gallery, New York

Plate 7 Ellen Gallagher (b. 1965, Providence, RI; based in New York and Rotterdam), *An Experiment of Unusual Opportunity*, 2008. Ink, graphite, oil, varnish, and cut paper on canvas, 79 ½ × 74 in. (201.9 × 188 cm). Collection of Larry Gagosian (promised gift to the Metropolitan Museum of Art). © Ellen Gallagher. Courtesy Gagosian

Plate 8 Dean Byington (b. 1958, Santa Monica; based in Oakland), *The Inquisitors*, 2011. Oil on linen, 65 × 70 in. (165.1 × 177.8 cm). Pizzuti Collection. © Dean Byington

Plate 9 Jeremy Blake (b. 1971, Fort Sill, OK; d. 2007, New York), *Winchester*, 2002. Digital animation with sound on DVD, 18 minutes. Collection Nerman Museum of Contemporary Art, Johnson County Community College, Overland Park, Kansas, Gift of Marti and Tony Oppenheimer and the Oppenheimer Brothers Foundation. © Jeremy Blake

Plate 10 Nogah Engler (b. 1970, Tel Aviv; based in London), *Circling*, 2014. Oil on canvas, 59 × 79 in. (149.9 × 200.7 cm). Pizzuti Collection. © Nogah Engler

Plate 11 Ali Banisadr (b. 1976, Tehran; based in New York), *Contact*, 2013. Oil on linen; support: 82 × 120 in. (208.3 × 304.8 cm). Collection Albright-Knox Art Gallery, Buffalo, New York; Gift of Mrs. Georgia M. G. Forman, by exchange; Bequest of Arthur B. Michael, by exchange; Elisabeth H. Gates Fund, by exchange; Charles W. Goodyear and Mrs. Georgia M. G. Forman Funds, by exchange; Philip J. Wickser Fund, by exchange; Gift of Mrs. Seymour H. Knox, Sr., by exchange; Gift of Miss Amelia E. White, by exchange, 2014, 2014:8. © Ali Banisadr. Photo: Tom Loonan

Plate 12 Ahmed Alsoudani (b. 1975, Baghdad; based in New York), *X-Ray*, 2016. Acrylic, charcoal, and colored pencil on canvas, 82 × 64 in. (208.3 × 162.6 cm). Courtesy of the artist and Marlborough Contemporary. © Ahmed Alsoudani

Plate 13 Ahmed Alsoudani (b. 1975, Baghdad; based in New York), *Birds*, 2015. Acrylic, charcoal, and colored pencil on canvas, 82 × 52 in. (208.3 × 132.1 cm). Courtesy of the artist and Marlborough Contemporary. © Ahmed Alsoudani

Plate 14 Rokni Haerizadeh (b. 1978, Tehran; based in Dubai), *But a Storm Is Blowing from Paradise*, 2014. Ten parts of a twenty-four-part work: gesso, watercolor, and ink on inkjet prints; each 11 ¾ × 15 ¾ in. (30 × 39.9 cm). Solomon R. Guggenheim Museum, New York; Guggenheim UBS MAP Purchase Fund, 2015.89.1, 2015.89.5, 2015.89.7, 2015.89.9, 2015.89.10, 2015.89.11, 2015.89.16, 2015.89.17, 2015.89.18, 2015.89.20. © Rokni Haerizadeh

Plate 15 Wangechi Mutu (b. 1972, Nairobi; based in New York and Nairobi), *Untitled* from *Tumors*, 2004. Acrylic, ink, collage, and contact paper on Mylar, 49 × 42 in. (124.5 × 106.7 cm). Pizzuti Collection. © Wangechi Mutu. Image courtesy the artist and Gladstone Gallery, New York and Brussels

Plate 16 Wangechi Mutu (b. 1972, Nairobi; based in New York and Nairobi), *Funkalicious fruit field*, 2007. Ink, paint, mixed media, and plastic pearls on Mylar; each: 92 $\frac{1}{8}$ × 53 in. (234 × 134.6 cm); overall: 92 $\frac{1}{8}$ × 106 in. (234 × 269.2 cm). Collection of Glenn Scott Wright, London. Courtesy the artist and Victoria Miro, London. © Wangechi Mutu. Image courtesy the artist and Victoria Miro, London

Plate 17 Ghada Amer (b. 1963, Cairo; based in New York), *The Egyptian Lover*, 2008. Acrylic, embroidery, and gel medium on canvas, 62 × 78 in. (157.5 × 198.1 cm). Collection of Miyoung Lee and Neil Simpkins, New York. © Ghada Amer. Photo: Courtesy Cheim & Read, New York

Plate 18 Ghada Amer (b. 1963, Cairo; based in New York), *Revolution 2.0*, 2011. Embroidery and gel medium on canvas, 70 × 59 in. (177.8 × 149.9 cm). Collection of Miyoung Lee and Neil Simpkins, New York. © Ghada Amer. Photo: Courtesy Cheim & Read, New York

Plate 19 Ali Banisadr (b. 1976, Tehran; based in New York), *Treasure*, 2016. Oil on linen, 66 × 88 in. (167.6 × 223.5 cm). Collection of Joshua Rechnitz. © Ali Banisadr

Plate 20 Eddy Kamuanga Ilunga (b. 1991, Kinshasa, Democratic Republic of the Congo; based in Kinshasa), *Tambour II*, 2015. Acrylic and oil on canvas, 59 $\frac{1}{8}$ × 59 $\frac{1}{8}$ in. (150 × 150 cm). Mott-Warsh Collection, Flint, Michigan. © Eddy Kamuanga Ilunga

Plate 21 Jiha Moon (b. 1973, Daegu, South Korea; based in Atlanta), *Pied de grue*, 2012. Ink and acrylic, fabric, and embroidery patches on *hanji* (mulberry paper), 47 × 72 in. (119.4 × 182.9 cm). Courtesy of the artist, Curator's Office, Washington, DC, and Ryan Lee Gallery, NY. © Jiha Moon

Plate 22 Jiha Moon (b. 1973, Daegu, South Korea; based in Atlanta), *Springfield—Butterfly Dream*, 2010. Ink and acrylic, fabric, and embroidery patches on *hanji* (mulberry paper), 81 $\frac{1}{2}$ × 30 in. (207 × 76.2 cm). Courtesy of the artist and Curator's Office. © Jiha Moon

Plate 23 Wade Guyton (b. 1972, Hammond, IN; based in New York), *Untitled*, 2005. Epson UltraChrome inkjet on linen, 59 × 35 $\frac{3}{8}$ in. (150 × 90 cm). Collection of Miyoung Lee and Neil Simpkins, New York. © Wade Guyton. Image courtesy of Petzel, New York

Plate 24 Wayne Gonzales (b. 1957, New Orleans; based in New York), *Untitled*, 2009. Acrylic on canvas, 84 × 84 in. (213.4 × 213.4 cm). Collection of the artist. © Wayne Gonzales. Image courtesy of Stephen Friedman Gallery, London

Plate 25 Wayne Gonzales (b. 1957, New Orleans; based in New York), *Waiting Crowd*, 2008. Acrylic on canvas, 78 × 78 in. (198.1 × 198.1 cm). Solomon R. Guggenheim Museum, New York. Partial gift of the artist and purchased with funds contributed by the International Director's Council and Executive Committee Members: Tiqui Atencio Demirdjian, Christina Baker, Janna Bullock, Rita Rovelli Caltagirone, Dimitris Daskalopoulos, Harry David, Caryl Englander, Laurence Graff, Nicki Harris, Dakis Joannou, Rachel Lehmann, Linda Macklowe, Peter Norton, Katharina Otto-Bernstein, Tonino Perna, Inga Rubenstein, Simonetta Seragnoli, Cathie Shriro, Ginny Williams, and Elliot K. Wolk, and Sustaining Members: Linda Fischbach and Cargill and Donna MacMillan, 2009, 2009.22. © Wayne Gonzales

Plate 26 Wayne Gonzales (b. 1957, New Orleans; based in New York), *Untitled*, 2007. Acrylic on canvas, 84 × 126 in. (213.4 × 320 cm). Courtesy of the artist. © Wayne Gonzales

Plate 27 Corinne Wasmuht (b. 1964, Dortmund, Germany; based in Berlin), *Bibliotheque/CDG-BSL*, 2011. Triptych: oil on wood mounted on aluminum; each panel: 83 × 95 in. (210.8 × 241.3 cm); overall: 83 × 285 in. (210.8 × 723.9 cm). Collection Albright-Knox Art Gallery, Buffalo, New York; Sarah Norton Goodyear Fund, 2011, 2011:44a-c. © Corinne Wasmuht. Image courtesy of the artist and Petzel, New York

Plate 28 Rachel Rossin (b. 1987, West Palm Beach; based in New York), *I Came And Went As A Ghost Hand (Cycle II)*, 2015. Virtual reality. Courtesy of the artist and ZieherSmith Gallery. © Rachel Rossin

Plate 29 Korakrit Arunanondchai (b. 1986, Bangkok; based in New York and Bangkok), *Untitled (Body Painting 9)*, 2013. Acrylic paint, denim, and inkjet print on canvas, 86 × 64 in. (218.4 × 162.6 cm). Courtesy of the artist and C L E A R I N G New York/Brussels. © Korakrit Arunanondachai

Plate 30 Barnaby Furnas (b. 1973, Philadelphia; based in New York), *Untitled (Flood)*, 2007. Urethane on linen; support: 84 × 140 in. (213.4 × 355.6 cm). Collection Albright-Knox Art Gallery, Buffalo, New York; Sarah Norton Goodyear Fund, 2010, 2010:12. © Barnaby Furnas. Photo: Tom Loonan

Plate 31 Julie Mehretu (b. 1970, Addis Ababa, Ethiopia; based in New York), *Conjured Parts (core)*, 2016. Ink and acrylic on canvas, 60 × 72 in. (152.4 × 182.9 cm). Private collection, Phoenix, AZ. © Julie Mehretu. Photo: Tom Powell Imaging

Plate 32 Pat Steir (b. 1940, Newark, NJ; based in New York), *White Moon Mist*, 2006. Oil on canvas, 72 × 72 in. (182.9 × 182.9 cm). Collection of Teresa and Bryan Lipinski, Nashville. © Pat Steir

Plate 33 Charline von Heyl (b. 1960, Mainz, Germany; based in New York and Marfa, TX), *Melencolia*, 2008. Acrylic, oil, and charcoal on linen, 85 ½ × 82 ½ in. (217.2 × 209.6 cm). Mildred Lane Kemper Art Museum, Washington University in St. Louis; University purchase with funds from the David Woods Kemper Memorial Foundation, 2011, WU 2011.0004. © Charline von Heyl. Image courtesy of Petzel, New York

Plate 34 Barbara Takenaga (b. 1949, North Platte, NE; based in New York), *Black Triptych (blaze)*, 2016. Acrylic on linen, 72 × 108 in. (182.9 × 274.3 cm). Courtesy of the artist and DC Moore Gallery, New York. © Barbara Takenaga

Plate 35 Matti Braun (b. 1968, Berlin; based in Cologne), *Untitled*, 2012. Fabric dye on silk, and coated aluminum frame, 40 × 32 in. (101.6 × 81.3 cm). Collection of Candace Worth. © Matti Braun

Plate 36 James Perrin (b. 1975, Kenton, TN; based in Nashville), *Semiosis on the Sea*, 2015. Oil on linen with acrylic resin, plant resin, paint scraps, and Tahitian pearls, 45 × 64 in. (114.3 × 162.6 cm). Courtesy of the artist. © James Perrin

Plate 37 Heather Gwen Martin (b. 1977, Saskatoon, Canada; based in Los Angeles), *Trigonometric Functions*, 2010. Oil on linen, 60 × 84 in. (152.4 × 213.4 cm). Hallmark Art Collection, Kansas City, Missouri. © Heather Gwen Martin

Plate 38 Matthew Ritchie (b. 1964, London; based in New York), *A bridge, a gate, an ocean*, 2014. Oil and ink on canvas, 94 × 120 × 2 ½ in. (238.8 × 304.8 × 6.4 cm). Courtesy of the artist. © Matthew Ritchie

Plate 39 Matthew Ritchie (b. 1964, London; based in New York), *Monstrance*, 2014. Single-channel video installation, dimensions vary. Courtesy of the artist. © Matthew Ritchie

Plate 40 Dannielle Tegeder (b. 1971, Peekskill, NY; based in Brooklyn), *Lightness as it Behaves in Turbulence*, 2016. Acrylic on canvas, 60 × 48 in. (152.4 × 121.9 cm). Courtesy of the artist and Carrie Secrist Gallery, Chicago. © Dannielle Tegeder

Plate 41 Dannielle Tegeder (b. 1971, Peekskill, NY; based in Brooklyn), *Nocturnal System Drawing and Atomic Nightlight*, 2009–11. Gouache, ink, colored pencil, graphite, and pastel on Fabriano Murillo paper, 55 × 79 in. (139.7 × 200.7 cm). Collection of Caren Golden, New York. © Dannielle Tegeder

Plate 42 Hamlett Dobbins (b. 1970, Knoxville, TN; based in Memphis, TN), *Untitled (For M.R.M./J.N./D.G.G.)*, 2016. Acrylic on canvas, 46 × 54 in. (116.8 × 137.2 cm). Courtesy of the artist and David Lusk Gallery. © Hamlett Dobbins

Plate 43 Hamlett Dobbins (b. 1970, Knoxville, TN; based in Memphis, TN), *Untitled (For I.V./C.B.)*, 2016. Acrylic on canvas, 40 × 48 in. (101.6 × 121.9 cm). Courtesy of the artist and David Lusk Gallery. © Hamlett Dobbins

Plate 44 Sarah Walker (b. 1963, Bethesda, MD; based in Brooklyn), *Dust Tail II*, 2008. Acrylic on paper, 48 × 48 in. (182.9 × 167.6 cm). Courtesy of the artist and PIEROGI, New York. © Sarah Walker

Plate 45 Sarah Walker (b. 1963, Bethesda, MD; based in Brooklyn), *Tanglement*, 2016. Acrylic on canvas, 72 × 66 in. (182.9 × 167.6 cm). Courtesy of the artist and PIEROGI, New York. © Sarah Walker

Plate 46 Kazuki Umezawa (b. 1985, Saitama, Japan; based in Japan), *Over the Sky of the Beyond*, 2014. Digital print, acrylic, and glitter paste on wood panel, 39 ⅜ × 48 ⅞ in. (100 × 124 cm). Pizzuti Collection. © Kazuki Umezawa

Plate 47 Guillermo Kuitca (b. 1961, Buenos Aires; based in Buenos Aires), *Everything*, 2004. Mixed media on canvas, 120 × 65 in. (304.8 × 165.1 cm). Indianapolis Museum of Art at Newfields, The Ballard Fund, 2007.1. © Guillermo Kuitca

Plate 48 Anoka Faruqee (b. 1972, Ann Arbor, MI; based in New Haven, CT), *2013P-83 (Wave)*, 2013. Acrylic on linen on panel, 45 × 45 in. (114.3 × 114.3 cm). Courtesy of the artist and Koenig & Clinton, New York. © Anoka Faruqee. Photo: Jeffery Sturges, New York

Plate 49 Anoka Faruqee (b. 1972, Ann Arbor, MI; based in New Haven, CT), *2013P-85*, 2013. Acrylic on linen on panel, 45 × 45 in. (114.3 × 114.3 cm). Hallmark Art Collection, Kansas City, Missouri. © Anoka Faruqee. Photo: Jeffery Sturges, New York, courtesy the artist and Koenig & Clinton, New York

Plate 50 Anoka Faruqee (b. 1972, Ann Arbor, MI; based in New Haven, CT), *2013P-68*, 2013. Acrylic on linen on panel, 45 × 45 in. (114.3 × 114.3 cm). Hall Collection, courtesy Hall Art Foundation. © Anoka Faruqee. Photo: Jeffery Sturges, New York, courtesy the artist and Koenig & Clinton, New York

Plate 51 Pedro Barbeito (b. 1969, La Coruña, Spain; based in Easton, PA), *LHC Blue* from *The God Particle*, 2014. Acrylic, pigment printout, and 3-D printout on canvas, 50 × 72 × 3 in. (127. × 182.9 × 7.6 cm). Courtesy of the artist. © Pedro Barbeito

Plate 52 Pedro Barbeito (b. 1969, La Coruña, Spain; based in Easton, PA), *LHC Red* from *The God Particle*, 2014. Acrylic, pigment printout, and 3-D printout on canvas, 50 × 72 × 3 in. (127 × 182.9 × 7.6 cm). Courtesy of the artist. © Pedro Barbeito

CONTRIBUTORS

MARK W. SCALA is the chief curator at the Frist Center for the Visual Arts. His major exhibitions have focused on the representation of the body in contemporary art. The most recent was *Phantom Bodies: The Human Aura in Art* (2015), which explored the subjects of loss and remembrance in contemporary art. *Fairy Tales, Monsters, and the Genetic Imagination* (2012) was an international survey on the theme of the hybrid body in folklore, science fiction, and genetic engineering. *Paint Made Flesh* (2009) was a compilation of expressionistic figure painting in the United States, Germany, and Britain since World War II.

A lecturer at the City College of New York and instructor at the Museum of Modern Art, New York, **MEDIA FARZIN** is a PhD candidate at the City University of New York. She is the author of essays on Kamrooz Aram, Monir Shahroudy Farmanfarmaian, Pouran Jinchi, and Anton Vidokle. Farzin has also contributed to TehranAvenue.com, *Afterimage*, *Art-Agenda*, *Bidoun*, and *Canvas*. Her collaboration with artist Alessandro Balteo Yazbeck, on cultural diplomacy and its modernist artifacts, was shown at the 12th Istanbul Biennial in 2011.

An artist and a writer on art, **SIMON MORLEY** is Assistant Professor at Dankook University, Republic of Korea. He is the author of *Writing on the Wall: Word and Image in Modern Art* (2003) and editor of *The Sublime* (2010), in the Documents of Contemporary Art series. His essays have appeared in the *Journal of Contemporary Painting*, *Third Text*, and *World Art*.

MATTHEW RITCHIE has been an artist in residence at the Getty Research Institute in Los Angeles and a Distinguished Senior Fellow at the University of Pennsylvania. He received an honorary doctorate from Montserrat College of Art in 2016 and is currently a mentor professor at Columbia University. Ritchie has contributed essays and articles to many publications, including *Art & Text*, *Artforum*, *Contemporary Arts Journal*, *Edge, Flash Art*, and *October*.